SWINDON
IN
50
BUILDINGS

ANGELA ATKINSON

AMBERLEY

First published 2019

Amberley Publishing, The Hill, Stroud
Gloucestershire GL5 4EP

www.amberley-books.com

British Library Cataloguing in Publication Data.
A catalogue record for this book is available from the British Library.

ISBN 978 1 4456 9047 6 (print)
ISBN 978 1 4456 9048 3 (ebook)

Typesetting by Aura Technology and Software Services, India.
Printed in Great Britain.

Contents

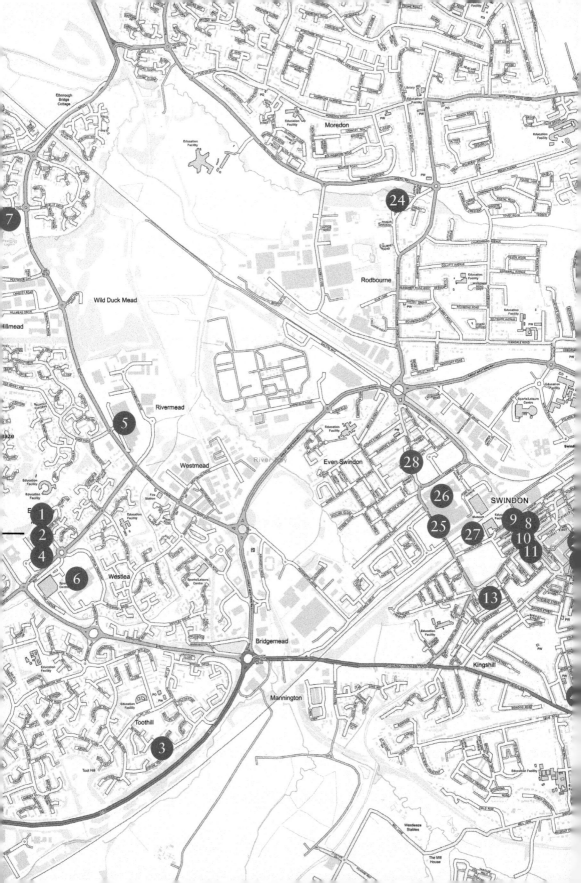

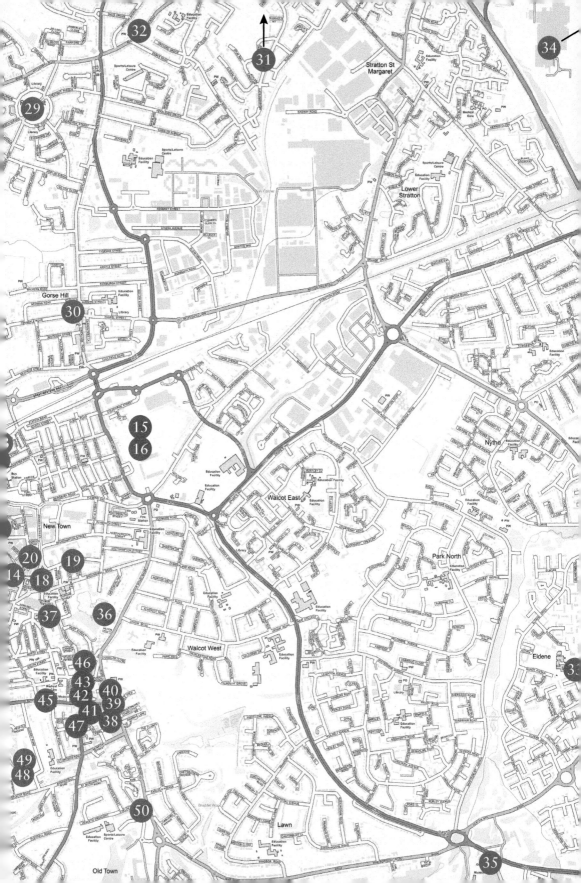

Key

West Swindon
1. St Mary's Church (SN5 3PA)
2. Lydiard House (SN5 3PA)
3. Toothill Farm (SN5 8AS) and Whitehill Farm (SN5 8LJ)
4. Wick Farmhouse (SN3 6LJ)
5. The Spectrum Building (SN5 7UT)
6. The West Swindon Centre (SN5 7DL)
7. The Chinese Experience (SN5 5EZ)

Central Swindon: The Railway Village Conservation Area
8. The GWR Railway Village (SN1 5BN)
9. The Mechanics' Institution (SN1 5BP)
10. Central Community Centre (SN1 5BP)
11. Milton Road Baths (SN1 5JA)

Central Swindon
12. Swindon Steam Laundry (Former) (SN1 1DY)
13. Cambria Place and Cambria Chapel (SN1 5DN)
14. The Town Hall (SN1 1QF)
15. Cricket Pavilion (SN1 2ED)
16. The County Ground (SN12ED)
17. The Hunter Building
18. Rudi's Bar (SN1 1PR)
19. The Civic Offices (SN1 2JH)
20. The Wyvern Theatre (SN1 1QN)
21. The David Murray John Tower (SN1 1LH)
22. The Brunel Centre (SN1 1LF)
23. The Allied Dunbar Tri-centre

Rodbourne
24. Rodbourne Manor
25. The Pattern Store (SN5 7JL)
26. The GWR Works (SN2 2DY)
27. St Mark's Church (SN1 5EH)
28. The Dolphin (SN2 2AF)

Pinehurst
29. The Pinehurst Estate (SN2 1QR)

Gorse Hill
30. St Barnabas Church (SN2 1BU)

Stratton St Margaret and Upper Stratton
31. Arkell's Brewery (SN2 7RU)
32. Boundary House (SN2 7QD)

Eldene
33. The Crumpled Horn (SN3 3RZ)

South Marston
34. Dryden Cottage and Ranikhet (SN3 4SN)

Coate
35. The Coate Farmhouse (SN3 6AQ)
36. Drove Road Villas
37. The Technical College (SN1 3EE)

Old Town
38. The Bell Inn
39. Vilett's House (SN1 3HB)
40. The Goddard Arms (SN1 3EG)
41. Apsley House (SN1 4BA)
42. Prospect Terrace
43. Christ Church (SN1 3HG)
44. The North Wilts Aerated Water Manufactory (SN1 3NE)
45. Yucca Villa (SN1 4AY)
46. The Swindon Advertiser Building
47. Swindon Arts Centre (SN1 4BJ)
48. Pavilion Kiosk in the Town Gardens
49. The Town Garden's Concert Bowl
50. The Old Nursery

Introduction

Very little architecture but a great deal of building.

In 1950, Swindon's council published *Studies in the History of Swindon*. The book contains a contribution from the poet John Betjeman. In it, Betjeman observed that 'there is very little architecture in Swindon but a great deal of building', by which he meant that architecture and building didn't become two discrete things until the nineteenth century. Only then did architecture become a profession and building a trade. And, of course, as Betjeman points out, it was the nineteenth century that saw the construction of most of the Swindon that he knew.

Betjeman's observation expanded to note that 'Swindon, instead of being a West Country town, looked on its outskirts at any rate, like any industrial suburb anywhere.' It appeared to express sadness about this state of affairs due to Swindon's location in the beautiful and varied countryside of the South West. I've always thought that he rather missed the point, because Swindon – New Swindon at any rate – *is* an industrial suburb. Hence, I'm somewhat at a loss as to why it would look like anything else. Though he did also say that Swindon is more interesting than many towns that are more beautiful – I rather like that. And he was right, Swindon is interesting.

Swindon has a great many listed buildings, not to mention scheduled monuments and three registered parks and gardens. In fact, the town has 659 listed buildings, which seems to me to be an astonishing number. But then England/Britain has more history than you can shake an ancient stick at. At almost every turn there's a biscuit tin lid or a calendar image. In the light of which, that figure could be quite standard.

Swindon in 50 Buildings, though, doesn't only concern itself with listed buildings. Nor only old buildings. Nor only buildings with architectural or historical merit. Rather, it features buildings that say something about some aspect of Swindon's story or play some role in it or matter because they're of their time. Thus, while some of the buildings I've selected are listed buildings, not all of them are. Nor are they necessarily old or of architectural merit.

The Railway Village Conservation Area and some buildings in Old Town excepted, I could no doubt find fifty different buildings that would equally say something about Swindon's always surprising and fascinating story. But I had to make choices. Choices that I expect to be contentious. For every building that I've included, someone is sure to say 'but what about building X?' But putting building X in the book wouldn't have left space for building Y. One could take a chunk of

Old Town and everything in the Railway Village Conservation Area and related buildings – the Outlet Centre, the Carriage Works et al. – and have fifty buildings of relevance to Swindon's story without breaking a sweat. But that wouldn't make for a well-balanced book.

So, I've aimed for a spread, both across time and geographic areas, to represent as much of Swindon as I can. Some architects you'll have heard of – the Casson/Condor partnership and Norman Foster, for example. (The former the creator of the Wyvern Theatre and the latter the designer of the landmark, award-winning Spectrum Building.) It's inevitable that others reflect Swindon's railway heritage and allied industries. All are stories forged in brick, concrete and metal that narrate a time before the railway came and changed everything, and beyond to modern Swindon.

The 50 Buildings

West Swindon

1. St Mary's Church, Lydiard Park: Thirteenth Century

I covered St Mary's Church at Lydiard Park in *Secret Swindon*, from chancel to nave to porch. Yet, I can't call complete any book concerned with Swindon's buildings and their part in its story without some small mention of it – hence its presence here.

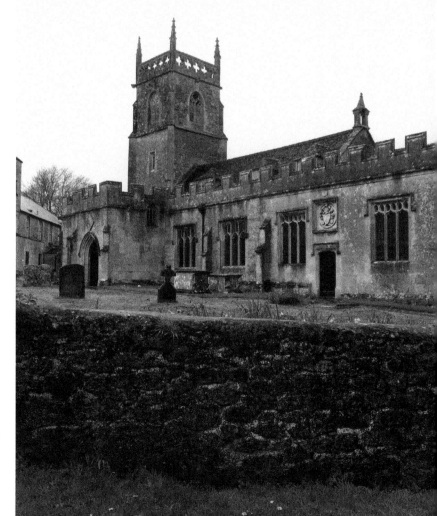

St Mary's
Church, Lydiard.
(Courtesy of
Roger Ogle)

Part of St Mary's interior. (Courtesy of Royston Cartwright)

As a Christian place of worship, in constant use since it welcomed its first congregation, St Mary's has stood on the edge of Lydiard Park for a good ten centuries. It holds a reputation as one of the country's best historic churches. Less in terms of its age, for there are many older churches in Britain, but more for its fine architecture and monuments spanning eight centuries.

We find the first recorded mention of the church at Lydiard Tregoze in 1100. Yet the earliest part of the church standing today dates from the thirteenth century. This period saw the construction of the north side and the nave. The south aisle was a fourteenth-century addition, while the bell tower (west tower) and the church's main entrance were fifteenth-century additions.

In the seventeenth century, the St John family constructed most of the grand monuments on the church's east side and in the side chapel.

2. Lydiard House: Seventeenth Century

This striking Grade I listed Palladian house housed the St John family for 500 years. Swindon wasn't Swindon as we know it when first the Tregoze clan, and later the St John family, put down roots here.

Leaf through the pages of the Domesday Book and you'll find reference to a settlement with woodland at Lediar, which was owned by the Tregoze family from around 1198. Sixty-one years later, in 1259, Henry III gave Robert Tregoze a royal licence to create a deer park in nearby woodland. By 1420, marriage brought the estate to the St John family. But it's to the seventeenth century we turn for the beginnings of the Lydiard House we know now. It was during this time that Sir John St John laid out formal gardens and a canal and made changes to the medieval house.

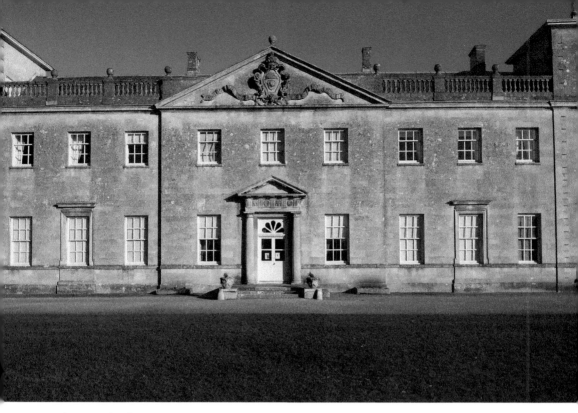

Above: Lydiard House.

Below: Showing the corner. (Courtesy of Roger Ogle)

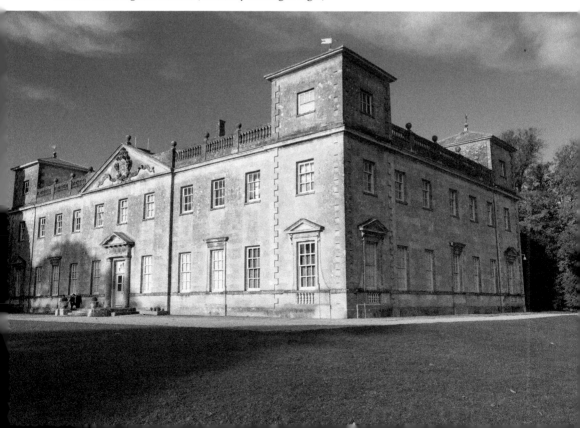

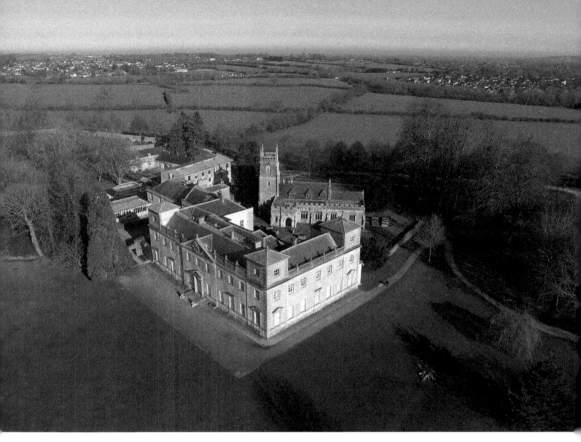

Aerial view showing Lydiard House and St Mary's Church. (Courtesy of Darren Jack)

By 1766 there'd been a removal of the garden's formal elements. Yet, surviving from the eighteenth century, there remains a semi-underground icehouse and a walled garden featuring a bronze sundial at its centre.

The decades of the 1920s and 1930s saw large parts of the Lydiard estate parkland sold off, while, during the war years, the remaining estate supported two different types of military service. First it served as a military hospital by American forces. Then, between 1943 and March 1946 (approximate dates) it housed a prisoner of war hospital for German soldiers – POW Camp 160.

Following the 1940 death of the Dowager Viscountess Bolingbroke, trustees took over the house and estate. But in 1943, the then local authority, the Corporation of Swindon, bought from the trustees, the by now dilapidated house and overgrown park.

In the eighteenth century it was common for such homes to have a grand bedroom and dressing room on the ground floor for the use of the family's high-status guests. Today this dressing room celebrates the 2nd Viscountess Bolingbroke, Diana Spencer – ancestor of Diana Spencer, Princess of Wales. There hangs a portrait of the 2nd Viscountess and the resemblance between her and her modern-day descendent is striking. The room also houses two special objects: the rare seventeenth-century painted window and the mechanical desk made by Giovanni Socchi in the early nineteenth century.

3. Toothill Farm (Bodiam Drive) and Whitehill Farm (Beaumaris Road): Seventeenth Century

As described in *Secret Swindon*, West Swindon is now a sprawling urban conurbation, first developed in the 1970s and 1980s. Before then, this area comprised little more than a few farmhouses, farmland, cottages and wide, open spaces. A single road ran through it to what is now Royal Wootton Bassett.

Remnants of this pre-railway, rural landscape remain in the forms of several farmhouses, of which these are only two. Toothill farmhouse lies on Bodiam Drive, while Whitehill farmhouse sits on the corner of Rowton Heath Way and Beaumaris Road.

During its long history, Toothill Farm has had many occupiers and owners. The Charterhouse governors administered the dairy farm at Toothill from 1605. Then Thomas Sutton, founder of the now famous school, acquired it along with the Whitehill and Mannington farms in the manor of Mannington.

In the seventeenth century, Whitehill Farm functioned as a 65-acre dairy farm. Along with the Mannington and Toothill farms, it formed part of the Charterhouse School estate in Lydiard Tregoze. The rents collected from the tenant farmers went to fund Charterhouse, a school that began life as a charitable venture to educate poor boys.

Come 1919, Wiltshire County Council bought the three farms and broke them up into smallholdings for ex-servicemen returning from the First World War. Swindon Borough Council currently own both properties.

Toothill farmhouse, 1979.

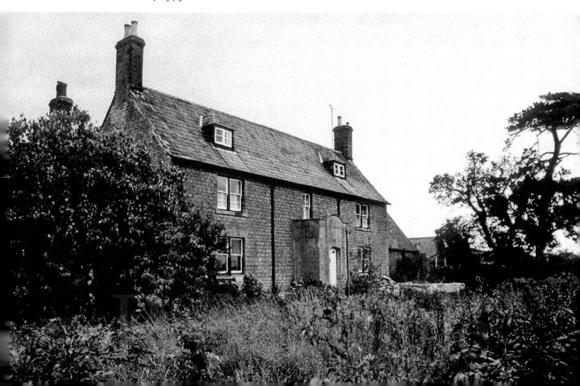

Left: Rear of Whitehill Farm, 1980s. (Courtesy of Roger Ogle)

Below: Whitehill farmhouse.

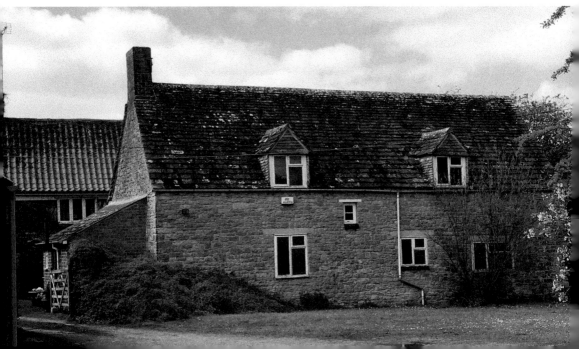

4. Wick Farmhouse: Seventeenth Century

Staying with the seventeenth century and West Swindon (as it is now) farmland, we come to Wick Farm. Now in private ownership and incorporated into a housing estate, Wick farmhouse had a former life as a St John property – as a 150-acre dairy farm on the Bolingbroke estate. According to the *Swindon Advertiser*, aerial photographs offer clear images of the ridge-and-furrow pattern of open-field farming.

Listed in 1986 for its special architectural or historic interest, Wick Farm now nestles at the centre of a housing estate – the Prinnells. Follow the West Swindon sculpture trail and you'll see a lovely old stained-glass window in the side of what was once a barn on the farm.

In the nineteenth century, Wick Farm housed one Jonas Clarke Snr for over twenty-six years. Considering the social mores of Victorian society, the Clarkes were an unconventional bunch. A lot more than crops were sown here. Jonas married in his late twenties, but soon formed a relationship with a servant girl by the name of Alice Pinnell. It took the passage of thirty years, the birth of seven children and the death of Jonas' wife before the pair could marry at St Mary's Church, Lydiard Tregoze, in 1853.

Jonas Snr died in 1862 and the farm's tenancy passed to his son, Jonas Clarke Jr. And so began an as yet unsolved Victorian mystery involving the possible falsification of census records. This was after all a desirable property that the Clarke family didn't want to lose their stake in. But I fear I don't have the space to go into the story in full here.

Wick Farm, mid-1980s. (Courtesy of Roger Ogle)

Wick Farm, 2013. (Courtesy of Roger Ogle)

Suffice to say then that Jonas Snr's grave is in the churchyard at St Mary's – to the left of the gates. Jonas Jr lies somewhere there too at an unknown location. His grave is as elusive as clarity surrounding the circumstances of his death.

5. The Spectrum Building (aka the Renault Building): 1982

In their 2004 document 'Buildings of Significant Local Interest', Swindon Borough Council (SBC) characterise the Spectrum Building as 'one which has received an award in recognition of the quality of its architectural design or other significance from a body of recognised local, regional or national standing'. As such, it earns its place here. Besides which, I like it.

Built in 1981–82 as a warehouse and distribution centre for vehicle components for the car company Renault, it's the creation of Sir Norman Foster. Featuring yellow steel 'umbrella masts', the 1981/82 futuristic glass-walled building merits its description by Roger Bowdler of English Heritage as a fine example of a high-tech building.

Once completed, the Renault Centre received widespread admiration, winning several awards. Madam La Lumiere, the then French Secretary of State for Consumer Affairs, performed the official opening on 15 June 1983.

In 1985 the building found its fifteen minutes of fame, as prescribed by Andy Warhol, when it featured in the James Bond film *A View to a Kill.*

The Spectrum Building achieved Grade II listed status in 2013, thus demonstrating that listed buildings don't have to be of traditional architectural design – as we shall see again later.

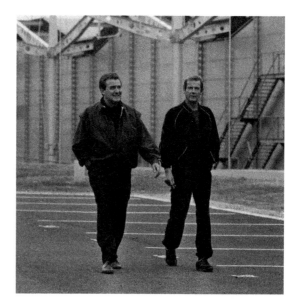

Right: Roger Moore and Patrick Macnee during filming for *A View to a Kill*, Calyx Pictures.

Below: Inside the Spectrum Building under Renault's ownership, showing cars suspended from ceiling. (Courtesy of Roger Ogle)

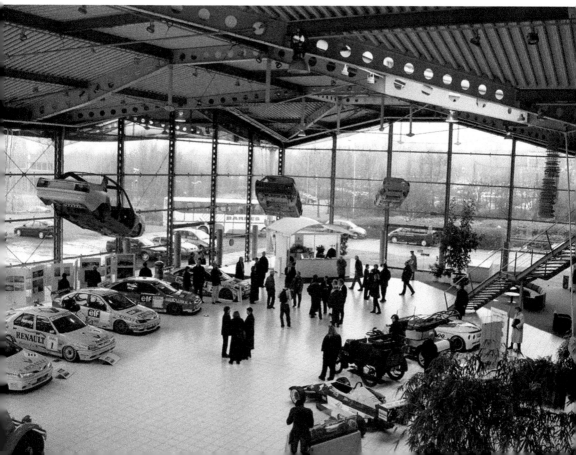

6. The West Swindon Centre: 1984

A 1968 report, 'Swindon: A Study for Further Expansion', outlined a plan for the growth of the town westwards into north Wiltshire. From the outset, planners identified a need for commercial and leisure facilities to serve the people moving into the proposed housing areas. They intended each housing area to have a small shopping area provision of its own, with a district centre of shops, services, recreation and entertainment in the middle.

A rough 3.2 km from Swindon's town centre lies the West Swindon centre, the heart of the aforementioned western expansion that included Toothill, Westlea, Eastleaze, Grange Park, Freshbrook, Shaw, Ramleaze, Middleleaze and the Prinnels.

Soon after the first residents of the first 10,000 homes arrived in March 1976, planning began on offering the land (jointly owned by Thamesdown Borough Council and EH Bradley & Son) to commercial developers for Swindon's first large-scale out-of-town commercial centre.

One design, from Linwood Ltd, stood out: a large building housing a main anchor store, a mall of small shops and external units arranged around a 'town square' with oodles of free parking.

Building began in the early part of 1980. In October 1981, the French supermarket chain Carrefour opened in the main anchor store, just in time for Le Beaujolais Nouveau. With their arrival, West Swindon went all Gallic, with the in-store bakery, *fromage* and *poisson* counters and the *boucher*. Not to mention an in-store *sommelier*. All of which saw West Swindon's epicurean horizons well and truly broadened.

In Swindon Central Library's local studies area, there's a wonderful four-page supplement to the *Link* magazine promoting the store. Years ahead of their time, Carrefour were keen to promote an absence of impulse purchases at the checkouts: no sweets, razor blades or magazines. 'Checkouts are for checking-out, as quickly and efficiently as possible,' it reads. They also advocated the recycling of cardboard boxes and plastic shopping bags.

Early view of West Swindon Centre, showing Carrefour. (Courtesy of Brian Carter)

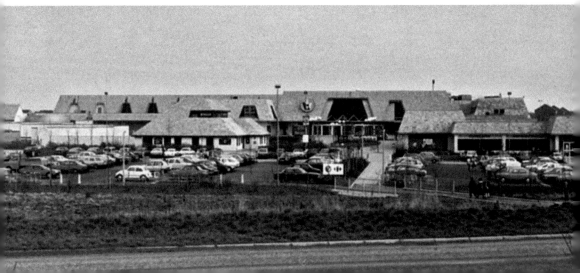

Gateway stores later took over Carrefour in the UK, only to undergo takeover themselves by Asda. These days the West Swindon centre is rather more an Asda centre than anything else, the company having taken over more of the other units.

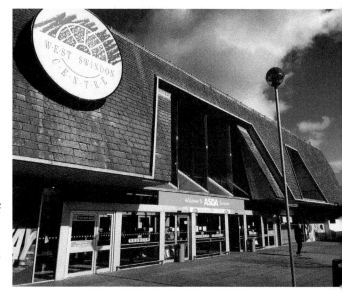

Right: West Swindon Centre, the district centre entrance. (Courtesy of Roger Ogle)

Below: Aerial view of West Swindon Centre and Link Centre. (Courtesy of Roger Ogle)

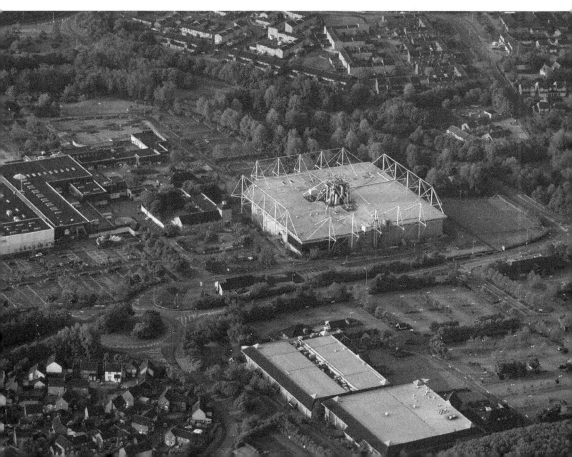

7. The Chinese Experience: 1989–90

In 2004, Swindon Borough Council (SBC) published *Buildings of Significant Local Interest*. In it, they categorise The Chinese Experience (now rebranded as the Hongzin Oriental Buffet after a period as the Pagoda Palace and the Oriental Buffet) as a building that has 'landmark quality or contributes to the character of an area or the quality of recognisable spaces, by virtue of its function, location, age, design or features'. For all that tells us, the Chinese Experience might be Swindon's answer to the Shanghai Marriage Market – up there on the Travel China Guide with the Nanjing Road and Disneyland as a top Shanghai attraction. But what it is, of course, is a Chinese restaurant sitting on a 2.5-acre site beside Peatmoor Lagoon – West Swindon's equivalent to the Yellow River. There's a small island in the lagoon with a decorative pagoda on it.

Designed by a Swindon Company, Wyvern Architects, it is (or at least was at the time of its opening) the UK's largest Chinese restaurant. It's built in a pagoda style – thus giving rise to its landmark quality ascribed by SBC. I imagine it's not all that often one chances upon a massive Chinese pagoda amid a 1980s urban conurbation. It boasts 6,883 square feet of space across two floors with well-travelled roof tiles shipped from Taiwan.

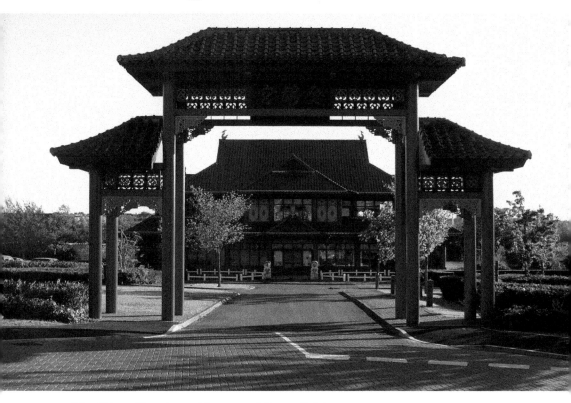

The Chinese Experience. (Courtesy of Roger Ogle)

Central Swindon: The Railway Village Conservation Area

8. The GWR Railway Village: 1841

If civil engineer Isambard Kingdom Brunel and mechanical engineer Daniel Gooch hadn't put their railway works where they did – at the foot of Swindon Hill – Swindon as we know it wouldn't exist. Hence, it's impossible to exclude the Railway Village as an entity from this book.

On 19 March 1842, Brunel presented to the directors of the Great Western Railway plans and drawings for the first 300 cottages to sit parallel to the main line.

Separated by open ground from the main line and the new workshops, these first dwellings were visible to passing trains. Thus, Brunel dressed them to impress passengers, with Elizabethan and Jacobean motifs on the stone-built façades. Think now of the aphorism 'all fur coat and no knickers'. For the cottage's dashing exteriors belied humble dwellings with rudimentary accommodation, no water and cesspits in the yards. Basically, Brunel blew the budget on the Jacobethan dressings, thus forcing him to economise elsewhere.

A model village in name, the settlement was far from model in other aspects. Thanks to overcrowding and suspect sanitation, a workers' utopia it was not. Yet, squalid living conditions aside, the GWR built houses of notable architectural

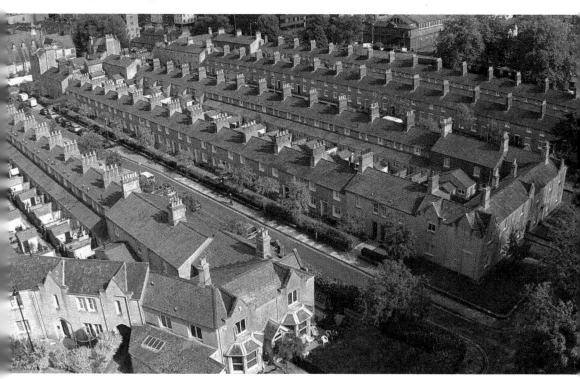

Aerial shot of Railway Village. (Courtesy of Martin Parry)

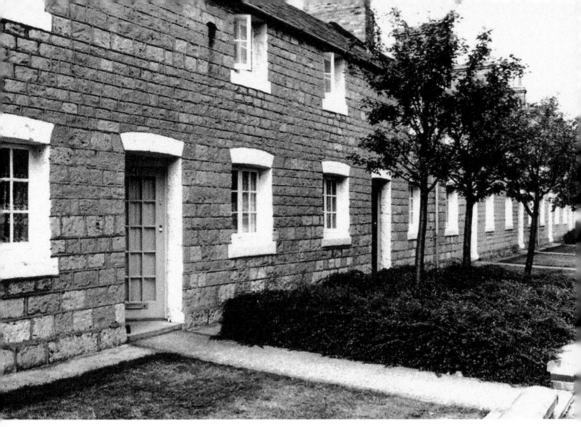

Above: One of the Railway Village streets. (Courtesy of Robin Earle)

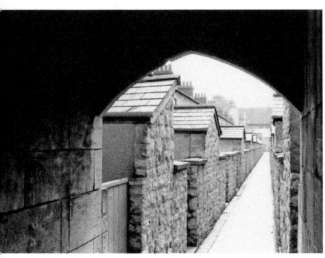

Left: View through the arch of the 'backsies'. (Courtesy of Robin Earle)

dignity and planning sophistication. Superior to most contemporary artisans' dwellings, they set a standard for later Swindon estates, which never offered the back-to-backs familiar in other British industrial settlements.

By November 1845 the need for more housing became acute. Gooch stated in correspondence that 'ten or twelve people were living in two rooms, and, when the night men got up the day men went to bed...' You've heard of hot-desking? Well, it was 'hot-bedding' here!

Until the 1995 English Heritage publication *Swindon: The Legacy of a Railway Town*, few recalled that Brunel himself designed the village. The fragility of history! Today it remains the last, and best, example of nineteenth-century railway workers' housing, celebrated among other model workers' settlements nationwide in a new promotional partnership.

In 2018, Swindon Civic Voice nominated the GWR Railway Village Conservation Area for a national award offered by the national Civic Voice movement. Following shortlisting by them and a groundswell of public support of staggering proportions, the village earned the wonderful title England's Favourite Conservation Area. And a glass trophy to prove it!

9. The Mechanics' Institution, Emlyn Square: 1854 (extensions in 1892, 1911, 1930)

One can argue with ease that this shamefully neglected Grade II* listed building could, and should, be the jewel of the Railway Village Conservation Area. That it's not, and looks instead something akin to Sleeping Beauty's bramble-bedecked, impregnable castle is given colourful voice by Mark Child in *The Swindon Book*. He said, 'the Mechanics' Institution building … has become, since the mid-1980s, the embodiment of the kind of obfuscation, nimbyism, bureaucracy, small-mindedness and muddled thinking that generally have previously stopped Swindon from elevating and successfully regenerating itself.' You can make your own mind up – I'm invoking my right to remain silent.

The Mechanics' Institution. (Courtesy of Martin Parry)

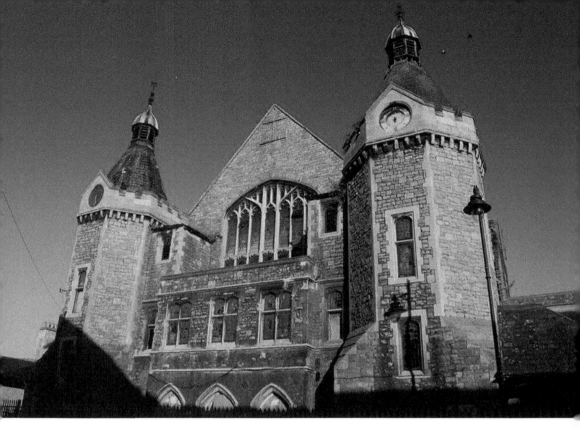

The Mechanics' Institution roof close up. (Courtesy of Martin Parry)

In happier times, the Mechanics' Institution building served as a venue for New Swindon's social, entertainment and educational activities.

Instigated by the Mechanics' Institute committee of the New Swindon Improvement Company, the building's Gothic Revival style came from the drawing board of Edward Roberts of London. In its glory days it offered a reading room, a theatre and a library – see *Secret Swindon* for so much more on all of that. It also boasted cold-water baths (before the building of the Milton Road Baths), a coffee room, a dining room, lecture rooms and public meeting rooms.

The day of the Mechanics' Institute stone-laying ceremony, 24 May 1854, was quite the red-letter day. *The Builder* magazine (Volume XII, 1854) on 'A Visit to Swindon New Town' said:

> On the 24th of May, a large party left the new London station of the Great Western Railway Company by a special train for Swindon, where, when they arrived, they found that other trains had already discharged their cargoes, and that the town was literally full of people: flags were flying, brass bands blowing, and everyone was in a bustle.

The importance of the Mechanics' Institution building lies both in its physical fabric and in what it represents. Along with the rest of the Railway Village Conservation Area, it symbolises the achievements of those who came from all corners of the

country. They converged in the new settlement, knowing only that there was opportunity. They built both a great railway and a great community. In ways too many to mention here, their history buffers national and even world history.

10. Central Community Centre, Emlyn Square: 1871

First an armoury, 1862. Then, from 1871, the Medical Fund Hospital and Dispensary. Then a Workers' Club from 1960 until 1979 village modernisation.

The focal Central Community Centre in the heart of the GWR Village Conservation Area began life as a conversion from the 1862 armoury built for the newly founded XI Wiltshire Volunteer Rifle Corps – one example of New Swindon's 'cut and paste' approach to development. This tactic saw the adaptation and even relocation of a surprising number of buildings as new needs arose.

By 1871, the opening of the Sawmill and Carriage Works necessitated the long-sought Accident and Emergency Hospital. The existing military hall morphed into the Medical Fund Society Hospital, complete with operating theatre. Adjacent cottages formed nurses' housing and a dispensary. Treating diseases wasn't on the

Central Community Centre.

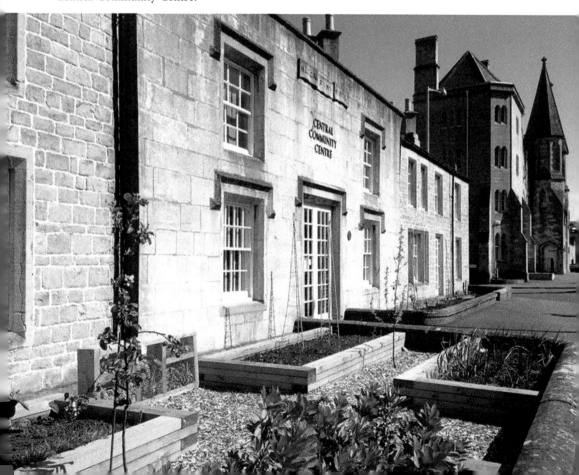

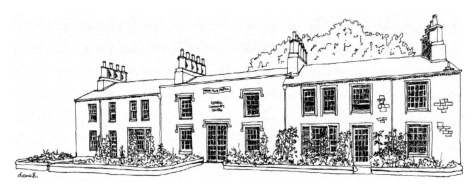

Sketch of the Central Community Centre today by Dona Bradley.

agenda at this point. The Medical Fund Society physician treated such cases in patients' homes or via referral letters sent to hospitals further afield.

The building once enjoyed a formal garden frontage, enclosed by iron railings. Here nurses wheeled patients out in their beds for fresh air. Though it's a moot point how fresh said air was, what with heavy coal smoke drifting in the air, executing a gradual blackening of the village's stonework.

In the fullness of time, the facilities on offer increased. Along came accident chairs, wheelchairs and airbeds, along with trusses, elastic stockings and assorted appliances. By 1930, the need arose to sacrifice the garden to allow the hospital to grow. This loss of flower beds allowed for forty-two patient beds, an X-ray department and a blood-donor service.

The year 1936 saw the addition of a nearby minor injuries A&E department added, along with a small operating theatre that, well, operated, until the Medical Fund Hospital closed. Swindon's health care provision soon came from the (now demolished) Princess Margaret Hospital – the first large general hospital built under the NHS.

11. Milton Road Baths (aka the Health Hydro), Milton Road/Faringdon Road: 1892–1906

This erstwhile HQ of the GWR Medical Fund Society is now mostly known as the Health Hydro, though interchangeably as The Baths, Milton Road Baths or the Old Health Centre.

The residents of the model village might have been the great unwashed in its early days. But that situation first changed in 1860 when the GWR installed Turkish baths in the Mechanics' Institution building. Then, in 1863, they transferred the baths to an area behind the barracks (a lodging house for unmarried GWR workers), also adding a slipper bath. (NB: A slipper bath is a freestanding bath with one end deeper than the other. During this time, the link was forged between cleanliness and health and so bathing became important in disease prevention.)

Above: Aerial view of the Health Hydro.
(Courtesy of Martin Parry)

Right: Blue plaque on Health Hydro.

BUILT 1892

GWR
MEDICAL FUND
HQ & BATHS
THE BLUEPRINT
FOR THE
NHS

SWINDON HERITAGE

In 1885 the trustees of the GWR Medical Fund Society bought a section of the Rolleston estate, on the south side of the Faringdon Road, for the sum of £999. This site became the location of the new dispensary and swimming baths. What with the old dispensary at the back of the hospital being oversubscribed and the 1868 swimming baths being without adequate facilities and ill-located within the works' site, the need was paramount.

Opening in 1892, the Swindon architect, J. J. Smith designed the building in the Queen Anne style and built it with bricks from the GWR's own brick works.

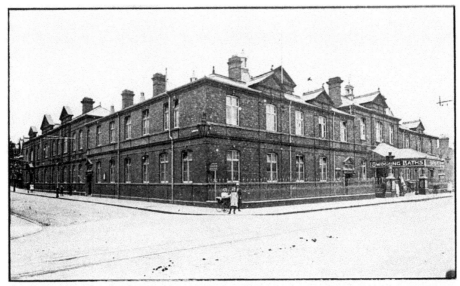

Dispensary and Baths

The Health Hydro in its Medical Fund Society heyday.

The Health Hydro is in essence four buildings – or at least building happened in four phases, with the swimming baths described above being the first stage. Then came a wash house to cope with the ever-increasing laundry load from the Medical Fund Hospital across the road. In 1898 came washing baths, followed by Turkish and Russian baths in 1899. The Turkish baths are the oldest extant Victorian Turkish baths in the world.

With the twentieth century, other services came along. In the period between the First World War and the mid-1940s eight additional consulting rooms came into use, along with a dental surgery, a psychological clinic, a dispensary, an ophthalmic practice, a chiropodist, a physiotherapist, a paediatric clinic, a skin clinic and a masseur.

Swindon's Medical Fund Society, conceived by the men for the men (and their families), and run by the men (via elected representatives), was a pioneering venture well ahead of its time, one that played a significant role on both local and national stages. A thing of beauty and breadth, the society was 101 years old when the NHS took it over.

Central Swindon

12. Swindon Steam Laundry (Former), Station Road/Aylesbury Street: 1841–76

This Grade II listed building is a rare and early example of a nineteenth-century cheese factory, and later a nineteenth-century industrial-scale steam laundry. It formed part of Swindon New Town's 1870s expansion, holding a prominent position opposite the railway station.

Right: The front of the Steam Laundry Building. (Courtesy of Lee Ferris)

Below: Corner view with a ghost sign: 'Southern Laundry'. (Courtesy of Lee Ferris)

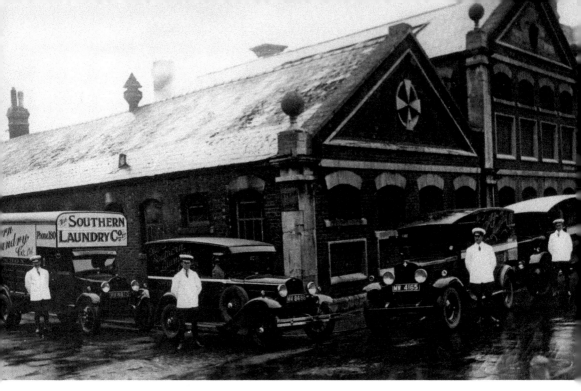

The Steam Laundry *c.* 1922. (Courtesy of Stevens Family Property)

The London-based Aylesbury Dairy Company built it between 1841 and 1876. The factory supplied dairy products to London via the Great Western Railway. In this and a myriad of ways, the GWR provided indirect employment – you gouda hand it to them.

In June 1891 the cheese factory closed, its contents sold via public auction and the building converted. It became the Swindon Steam Laundry Company, under the ownership of Robbins and Renshaw.

Plans drawn up in 1891 and signed by Swindon-based architects Ellis Herbert Pritchett (of Bishop & Pritchett Auctioneers & Architects (and that's not at all a mouthful) show the proposed alterations. The rear of the building had a delivery and distribution yard lined with horse boxes.

It will come as no surprise to anyone that early twentieth-century photographs show the laundry's staff were mostly women. Thus, the building boasted, if that's the word, a women's mess room and a hats and cloak room.

An Ordnance Survey map published in 1942 showed that the rear yard appeared to have been filled in. In the 1960s, before listing, the building remained in use as a commercial laundry. Alterations and extensions to the rear incorporated the one-time site of some terraced housing along Haydon Street. The upshot being the loss of the steam laundry's rear, including the boiler room, chimney and parts of the general wash house, the receiving and sorting room and the office and board room. As of November 2012, the wrecking ball did its thing with the 1960s extensions with Listed Building consent.

13. Cambria Place and Cambria Chapel: 1864

Once surfaced with ashes from the GWR Works, Cambria Place turns into Cambria Bridge Road. Built in the 1970s to carry traffic across the Wilts & Berks Canal, it affords excellent views of the southern terraces of the estate. It also features a magnificent mural/Swindon timeline representing key people and places in the town's history.

The manager of GWR's rolling mills, Thomas Ellis, formed a private company in 1863 to build Cambria Place for his taskforce of largely Welsh ironworkers. When they first arrived in New Swindon they had accommodation in the barracks (later a Wesleyan Chapel) in the Railway Village. The year 1864 saw their new settlement completed. The 1865 rate book records their new homes as a 'Welsh Colony'.

Damming a meandering stream of a story, Old Swindon first got fresh water pumped to it in 1868. Around the same time, these newly built Cambria cottages were the first New Swindon homes to get clean, piped water from a spring to the south, close to the Wilts & Berks canal.

These days, the busy Faringdon Road separates Cambria Place from the Railway Village Conservation Area. When first built, though, it was an established part of the railway community. In the nineteenth and the early part of the twentieth century, the residents used the long back gardens as small holdings for livestock, growing fruit trees and vegetables. The gardens backed onto what was once Swindon's canal. Long since filled in, it now forms a footpath to Swindon town centre.

Period side view of the chapel. (Courtesy of Martin Parry)

Left: Front view of the chapel today. (Courtesy of Chris Eley)

Below: Cambria Place. (Courtesy of Chris Eley)

Cambria's Baptist chapel is a Grade II listed building, living on now as a private home. For many years this tiny chapel conducted its services entirely in Welsh. You'll find technical architectural detail of the chapel on the website for British listed buildings.

14. The Town Hall, Regent Circus: 1890

The name of Ipswich's Brightwen Binyon looms large in many of Swindon's buildings. This Quaker architect designed, to name a few, the Mechanics' Institute extension, Gilbert's Hill School, Sanford Street School and New Swindon's Town Hall.

Designed in 1890, in the style of neo-seventeenth-century Dutch architecture, the two-storey Town Hall is a red-brick building with a distinctive 90-foot clock tower. Built as a centrepiece of New Swindon, the town's elders ensured the clock tower was taller than the one in Old Swindon. It couldn't be outdone by the 80-foot tower on Old Swindon's Corn Exchange – in particular because there was a clear view down on it from the Old Town on the hill.

At first occupied by the New Swindon Local Board's officials and those of the county court, in 1891 the building became the main Swindon Town Hall. From 1880 to 1900, the prospect of forming a single Swindon from the two separate ones (Old Swindon and New Swindon) preoccupied the towns. Such commentators as William Morris (founder and editor of the *Swindon Advertiser*) favoured a merger. Yet, of course, both councils held suspicions about the other's motives and were wary of their future status in a combined Swindon – as, indeed, one would be. In the wake of the GWR, New Swindon had grown in every way.

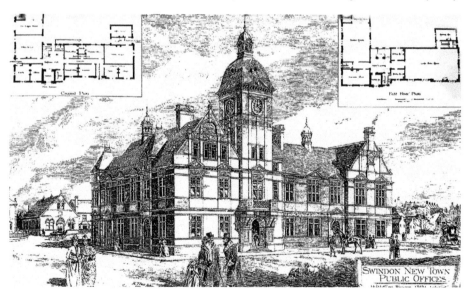

Period drawing of the Town Hall. (Courtesy of Micheal Grey)

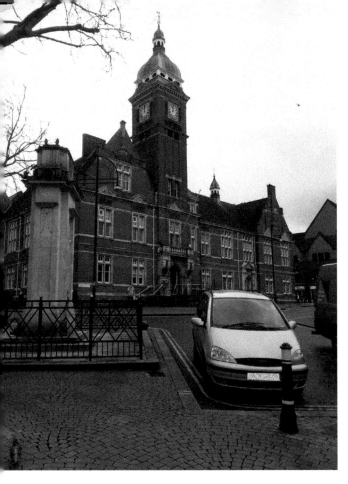

Town Hall and cenotaph.
(Courtesy of Chris Eley)

Holding a population majority and all the industry, its urban district council held the power. Amalgamation of the two, and the transference of civic functions to New Swindon's Town Hall, was inevitable.

The two towns remained separate until 1901. Then, in the last incorporation charter signed by Queen Victoria, the two became one.

Now, the New Swindon Urban District Council offices became the offices for the new borough. Thus, they remained until 1938 and the opening of the Civic Offices in Euclid Street.

The building now houses Swindon Dance, innovators in UK dance development for over three decades.

15. Cricket Pavilion, County Ground, County Road: 1893

Cricket must be Swindon's first organised sport – at any rate it was well established by the 1850s. The game has a long and convoluted history in the town. It's known that a group of gentry and businessmen established Swindon Cricket Club in 1844, though there's mention of leather hitting willow in Swindon two decades earlier.

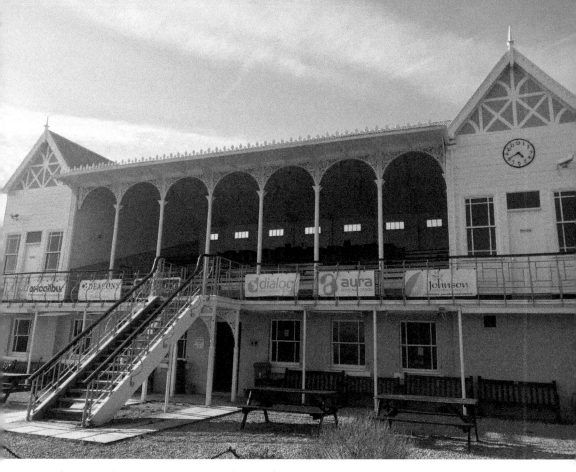

Above: Pavilion. (Courtesy of Swindon Cricket Club)

Below: Pavilion and players. (Courtesy of Swindon Cricket Cub)

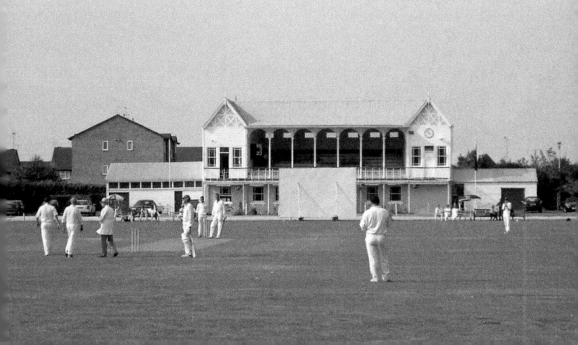

Cutting out several innings in the story, we come to 1893 and the construction of a cricket pavilion designed by W. H. Read and E. H. Pritchett. Still standing and now Grade II listed, the pavilion is a charming, elaborate structure of brick and wood with a cast-iron arcade. It has two storeys, nine bays and cost £850 to build.

The pavilion is brick built with a weather-boarded upper floor and a cast-iron and corrugated asbestos room. The first floor boasts a balcony resting on bellied iron brackets.

A document from Swindon Cricket Club records that the year 1891 saw:

- A very wet summer – plus ça change
- E.K Horne as Swindon's first match professional
- The establishment of the Wiltshire County Ground Co Ltd on 14th October to form a sport's centre
- The obtainment of an area of 25 acres, on the site of the present County Ground, from A.L and F.P Goddard on liberal terms.

Levelling and draining of the County Ground began in January 1892, along with the erection of two pavilions, one being the one we know today. The other, halfway down the ground, was later incorporated into buildings on the north side of the football ground.

In 1893, on 13 May, in glorious weather and attended by 6,000 people, the County Ground Sports Centre opened. Walter Long MP did the honours and an athletics and cycle meeting followed.

16. The County Ground, County Road: 1896

No town's story is complete without some mention of its sporting life. And Swindon's sporting life is rich enough. You can trace the origins of Swindon Town Football Club back to 1879. In the wake of the GWR's arrival in Swindon, her population boomed from 1,200 to 19,000 – with the majority living in New Swindon. One William Pitt, curate of Swindon's Christ Church, had the notion of a football team uniting the Old and New Town communities. He organised regular winter recreation for members of the Spartan's Cricket Club. In so doing he founded Swindon Association FC. So that's the nub of how the club began life, but what of its stadium?

After playing from a range of locations, the 1895/96 season saw the team move to their permanent home: the County Ground. The largesse of Thomas Arkell of Arkell's Brewery allowed for the construction of a stand on ground then called the Wiltshire County Ground. After one season's play on the site of what is now Wiltshire County Cricket Pitch, the club's landlords (the Wilts County Ground Company) attempted a rent increase. Discussions ensured, settlement was reached and a new stadium marked out where it remains to this day.

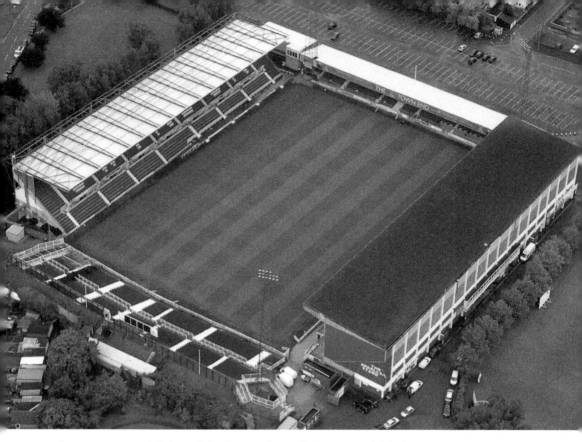

Contemporary aerial shot of the County Ground. (Courtesy of STFC)

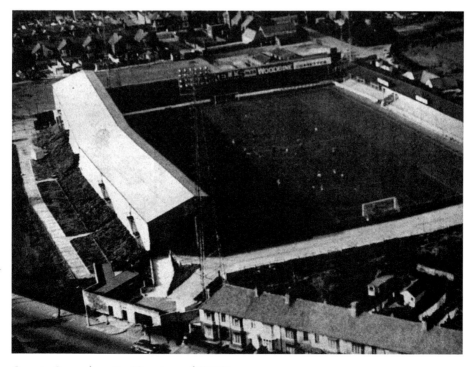

County Ground, 1962. (Courtesy of STFC)

Stand showing Deacon's clock. (Courtesy of STFC)

To finance the building of the first grandstand, on the north of the ground, the committee took on a loan. At the Mechanics' Institute, on Wednesday 14 April 1897, Swindon Town Football Co. Ltd came into being.

The year 1932 saw the erection of a covered stand on the Shrivenham Road side of the ground. A second-hand one bought at an Aldershot auction replaced it in April 1958. It provided 1,421 seats in the upper tier, the most expensive having a 6s (30p) ticket price. Two years later the club installed the existing 120-foot lighting pylons at a cost of £15,000.

In 1940, the War Department took over the ground and, for a period, housed POWs in huts on the pitch. The club received the princely sum of £4,570 in compensation for this inconvenience.

On the evening of Monday 2 April 1951, floodlit football came to Swindon – the first league club to be so illuminated. However, five years passed before the County Ground had its first floodlit league game.

17. The Hunter Building, No. 19e Regent Street: c. 1900

The aforementioned SBC 'Buildings of Significant Local Interest' document lists the Hunter Building as one that 'provides a good example of a particular type or form of building, or of an age, architectural style, building construction or design which is locally rare'. So far, so dry as dust. A blog I found on the topic of English buildings is more informative, however. It tells us that one William Wallace Hunter left London's East End in the late nineteenth century and came to Swindon.

By the 1890s, Hunter had a furnisher's shop in the town. Then 1901 saw his business installed in new premises on the corner of Edgeware Road and Regent Street. Furniture shops in the period were spacious and well lit, and Hunter's was no exception. Here, using expansive glass areas on both the ground and first floors, he created a showroom to display large pieces in a light, airy setting.

From 1900, thanks to the great GWR Works, Swindon became a town with an increasing population and corresponding opportunities for entrepreneurs. It's reasonable to suppose it's those factors that drew Hunter from London to Swindon in the first place. It's further reasonable to assume that he foresaw a good

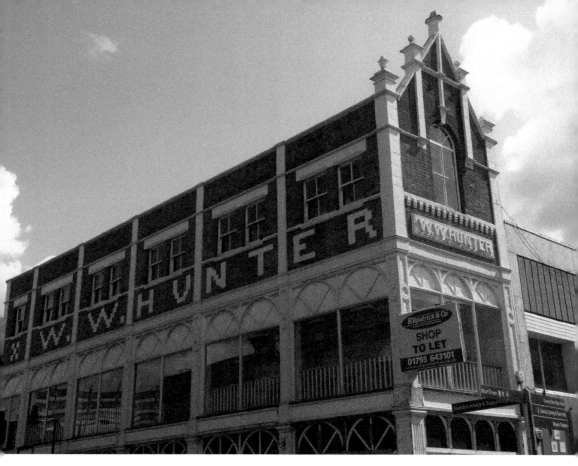

Above: Side view of the Hunter Building. (Courtesy of Chris Eley)

Below left and right: Hunter Building, Regent Street. (Courtesy of Chris Eley)

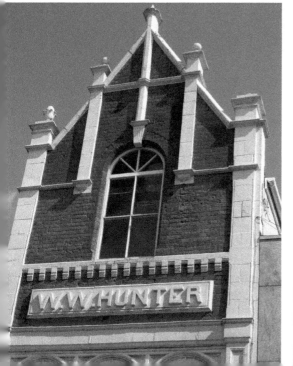
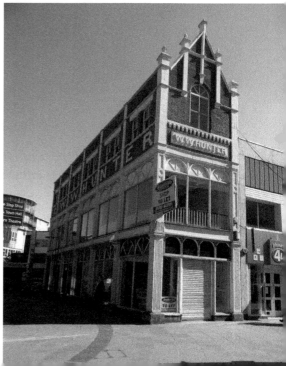

living and a long-standing business here. The evidence to support that supposition stares at us today. Well, if you raise your eyes up from shopfront level it does. Built into his shop's structure, in huge letters comprised of a tessellation of white-painted blocks on the long façade, are his name and initials: 'WW Hunter'. Such adornment suggests optimism, if nothing else. Indeed, the evidence suggests that his business did well. Hunter died in 1936, but the firm continued into the Second World War. It was not the level of longevity that three Old Town businesses – Deacon's, Blaylock's and Gilbert's – achieved, yet it was good going even so. And thus validated Wallace Hunter's decision to move to Swindon, set up business here and be part of its economic boom of the time.

18. Rudi's Bar (aka Swindon Corporation Electricity Showroom): 1934

There was a time, one I'm wont to yearn for when I'm comparing the market, when our energy supplies hadn't undergone deregulation. A time when white goods and heating appliances were neither as many and varied, nor as readily available as they are now. In these times every town and city in the land had electricity board showrooms and gas board showrooms. It was to these showrooms that the housewife trotted to pay the bills and buy appliances.

Exterior of the Electricity Board Showroom. (Courtesy of Swindon Museum and Art Gallery)

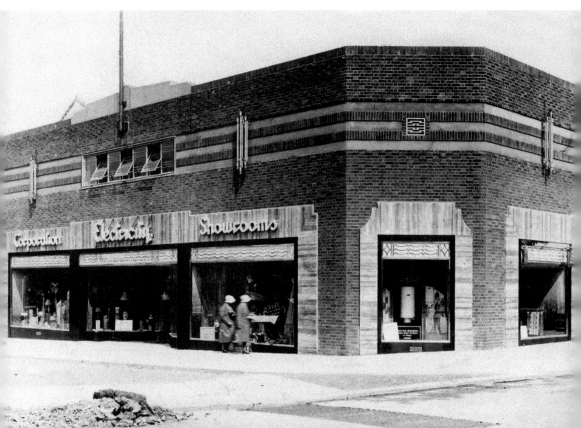

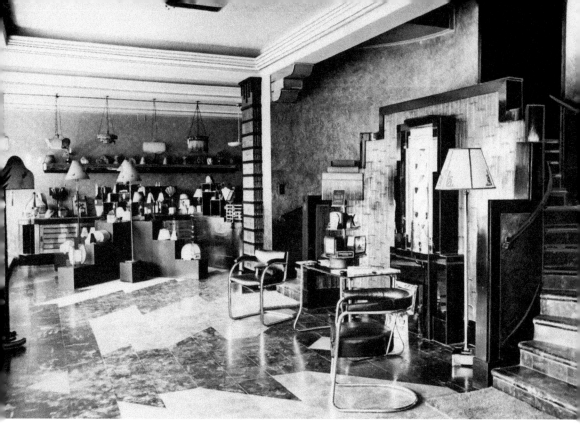

Above: An interior shot of Swindon's art deco Electricity Board Showroom. (Courtesy of Swindon Museum and Art Gallery)

Below: The Electricity Board Showroom today. (Courtesy of Chris Eley)

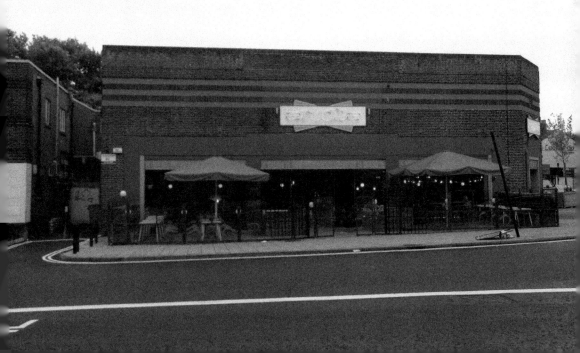

The art deco building at No. 21 Regent Circus that currently is Rudi's bar enjoyed a previous, and rather glamorous, existence as Swindon Corporation Electricity Showroom.

Mark Child's eponymous monograph on the building tells us: 'The Swindon Corporation electricity showrooms incorporated ladies' public toilets on the first floor, accessed by stairs on the north side of the building, and gentlemen's toilets … accessed by stairs from the east.' He goes on to state that the borough surveyor, J. B. L. Thompson, designed the property in the art deco style, while Richard James Leighfield & Sons of Whitney Street, Swindon, built it. Described as the last word in modernity apropos of its design, fittings and, indeed, its general planning thereof, the mayor (William Henry Bickham) declared it open on 19 April 1934. It was not he, though, who flicked on the lights for the first time. That delighted digit belonged to one H. R. Hustings, chairman of the Electricity Committee.

In 1937, the legendary David Murray John – he of the tower and shopping centre – became Swindon's town clerk. The building bearing his name symbolises the town's optimism and growth at that time. Yet the town's aspirations didn't begin there. Mark Child points out that this showroom was not erected in splendid isolation, showing off the style of the time, rather political motives underpinned it. Cited as the most important building erected since the formation of the borough, it sold a whole lot more than three-bar electric fires. It sold an objective, an intention, of being 'the forerunner of many such buildings … that would add to the amenities of Swindon and make it a more beautiful town'.

19. The Civic Offices: 1938

By 1936, the borough's population had risen to 60,400 souls. The associated municipal activities underwent a corresponding increase, rendering the Town Hall's provisions inadequate. Thus came the decision to erect new Civic Offices on Euclid Street.

Sounding like something out of an Agatha Christie novel, the Oxford firm Bertram, Bertram and Rice succeeded in getting the council, subject to some slight

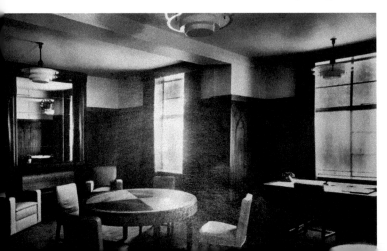

Interior showing the Mayor's Parlour. (Courtesy of Local Studies, Swindon Central Library)

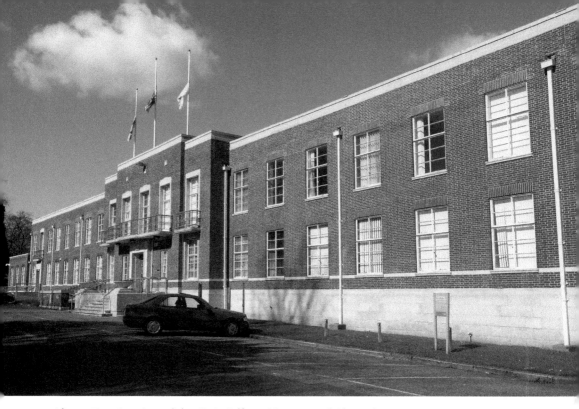

Above: Exterior view of the Civic Offices. (Courtesy of Chris Eley)

Below: The front of the Civic Offices. (Courtesy of Chris Eley)

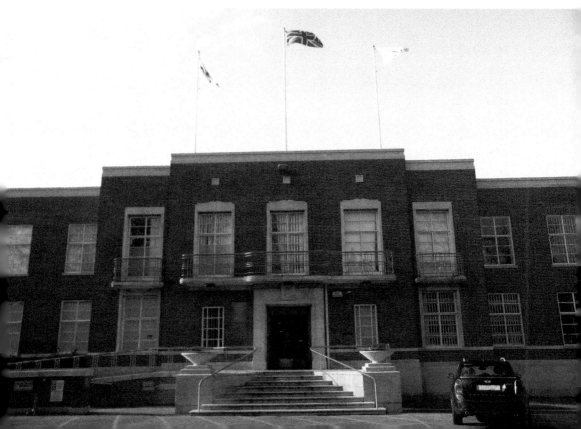

modifications, to accept their design. They won a national competition, from a field of sixty-seven other designers, judged by Arthur Bedford Knapp-Fisher, the then Professor of Architecture at the Royal College of Art.

The programme for the official opening describes this art deco building thus: 'The general character of the building is very simple, relying upon good proportion and massing, rather than elaborate detail to express its purpose of public use and service.' Further, it describes the Basildon facing bricks of the external walls and the Portland stone plinth and dressings to the main doors and windows.

It goes on to tell how the civic suite is centrally placed, with a dignified entrance and approach leading from the main entrance of the building. I've been in the civic rooms and they are lovely – all curves and polished wood. You get the idea from the old photo of the Mayor's Parlour that it's rather like stepping onto a *Poirot* set.

According to Mark Child's *The Swindon Book*, the Civic Offices formal gardens are the design of J. B. L. Thompson, the borough surveyor. It seems the pergola and rose arbour – still there today – were also his work.

So, it was then that, on Tuesday 5 July 1938, HRH the Duke of Gloucester K. G., attended by equerry-in-waiting Mr D. Scrymgeour-Wedderburn of the Scots Guards, performed the opening ceremony. As is only right and proper for a railway town, the GWR Staff Association Silver Band (Swindon) presented a rendition to the assembled company of 'God Save the King'.

20. The Wyvern Theatre: 1971 (opened)

HM the Queen, Elizabeth II, with Prince Philip two steps behind her as protocol demands, opened the proposed-but-never-realised Civic Centre, of which the Wyvern Theatre formed a part, in 1971.

In 1965, against a background of a Labour government adopting Jennie Lee's 1965 Policy for the Arts positing that the arts should be central to everyday life, Swindon's authorities brought in architects and planning consultants to develop their masterplan for a Civic Centre. A place for commerce, culture and entertainment to flourish cheek by jowl. A plan that involved demolition of the New Swindon Town Hall.

In February 1966, Casson-Condor persuaded the council to abandon their development plans in favour of a continuous range of civic buildings as a series of linked traffic-free spaces. Neville Condor designed the Wyvern along with some of the nearby buildings in the never-fully-realised scheme – the theatre being the first stage. In the end financial restrictions did for most of it, and only the theatre got built.

The theatre cost £199,296 or around £2.7 million in today's money. Condor designed the theatre on an unpretentious, informal and human scale. He created six particularly spacious dressing rooms for twenty-four people.

Over the years there have been several additions one could consider inappropriate for the modernist simplicity of the original building. The Wyvern

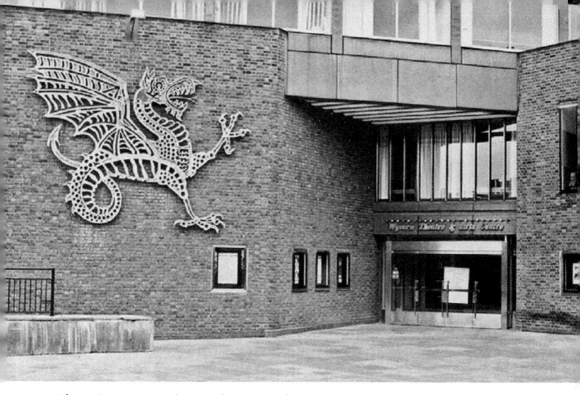

Above: A 1984 view showing the Wyvern dragon breathing towards the theatre's side entrance from Theatre Square. (Courtesy of Brian Carter)

Below: View of the Wyvern from the front entrance, 2018.

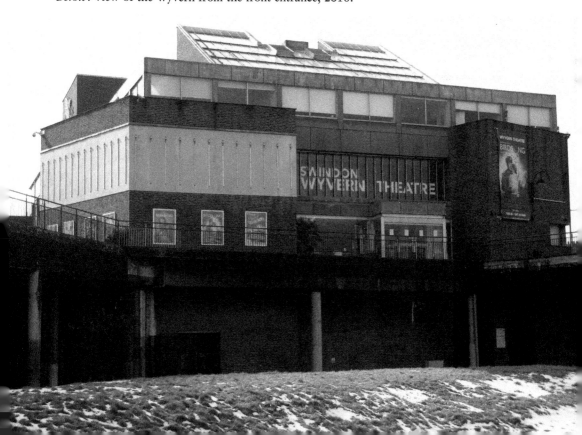

A side view of the theatre. (Courtesy of Chris Eley)

itself, the dragon from which the theatre takes its name, has flown from its original position, its fire now directed towards the Theatre Square entrance to up on the fly tower. In 2009, Icelandic artist Gudrun Haraldsdottir installed the light sculpture on the theatre's exterior.

21. The David Murray John Tower: 1976

Located in the heart of the Brunel Centre in Swindon town centre this, my favourite Swindon building, is often called the 'Brunel Tower' for its location at the heart of the Brunel Centre. In fact, though, this beautiful behemoth of a building is named after David Murray John. As clerk of Swindon Borough Council from 1938 to 1974, Murray John's energetic efforts played no small part in the post-Second World War influx of small industry into Swindon.

Glossing over the fact the Murray John harboured thoughts of razing the Railway Village, he was otherwise a man with a solid vison for Swindon. He ensured, as is fit for a railway town, that Swindon's post-war growth stayed on track. As it turned out, signing the final contract for the tower's construction back in 1974 was Murray John's last official duty. The sadness is that he died before its opening in 1976.

Murray John looked to the future, and so does the tower. Its curved, broad-shouldered, futuristic appearance set out to reflect the town's forward-looking aspirations. Hence, it's a building one can't ignore when telling Swindon's story through its buildings.

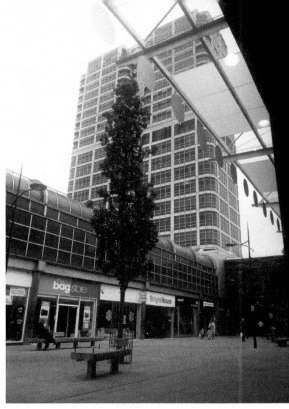

Above left: The David Murray John Tower reflected in puddle. (Courtesy of Chris Eley)

Above right: The David Murray John Tower and canal walk.

Below: The David Murray John Tower from a distance.

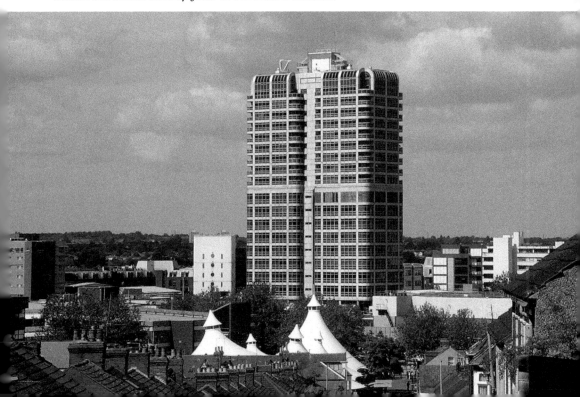

Clad in stainless steel – an expensive material even then – the building is sleek and sophisticated. It makes a statement, does the DMJ. At night a landlocked lighthouse, it screams at you to look at it. An act you can't avoid as it's visible for miles.

Douglas Stephen, the architect behind both the DMJ tower and the Brunel Centre, died some years ago, though his name lives on in the form of the Douglas Stephen Partnership.

The 83-metre-high building is largely residential – a mix of private and social housing – with offices on the first four floors.

Some years back, Jonathan Meades, essayist and architecture authority, placed the DMJ on his personal list of five extraordinary buildings in the world. Rubbing shoulders on a list including Marseille Cathedral, the Walhalla Temple in Bavaria, Cothay Manor in Somerset and Edinburgh's Stewart's Melville College, is Swindon's own DMJ. That singular fact pleases me no end.

22. The Brunel Centre: 1971–75

Sifting through a magazine file in local studies, in Swindon's central library, I came across this publication by Colin Amery: *The Architectural Review* September 1976, Vol. 160, 'Brunel Centre, Swindon: Architects: Douglas Stephen and Partners'. Scanning it, my eyes alighted on:

> …Swindon has acquired a touch of Milan. This new shopping arrangement has achieved what so many recent developments have lamentably failed to do. It has accepted the realities of the supermarket world, car parking and huge delivery areas and made them fit into an architectural framework that actually enhances their mundane nature. This is a considerable achievement that represents a clear victory over the purely commercial approach to the design of shopping centres…

Study the image of the centre when new and you'll recognise this description:

> The great success of the building is the main plaza. It's strongly evocative of the railway age in its roof, and the 'op' black and white floor is dazzling and spirited … The architects have given the great central space an agreeable anteroom with some reticent pavilions of shops around a leafy square. The statue of Isambard Brunel himself is a happy touch…

And indeed he was, though why the planners positioned him with his back to both the centre and his railway is a mite mystifying. Happily, a recent renovation of Havelock Square saw him turned around and looking down towards his Railway Village.

By the early 1970s, and despite being linked indelibly to Brunel's name and the GWR, Swindon was no longer only a railway town. Its position on the boundary

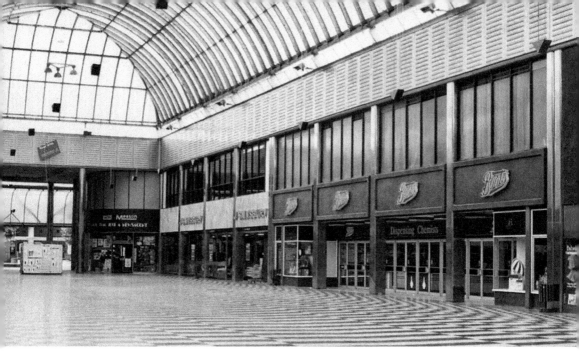

Above: Brunel Centre in
its early days. (Courtesy of
Carter Collectables)

Right: Current interior.
(Courtesy of Chris Eley)

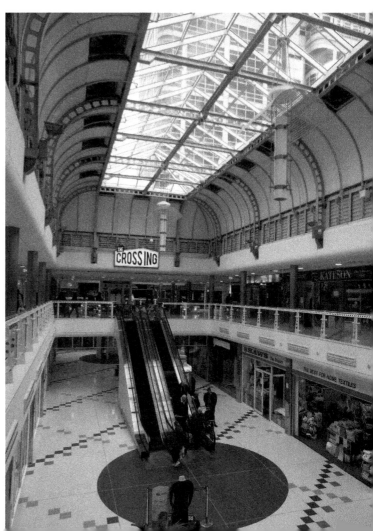

A view of the Brunel Centre from Canal Walk. (Courtesy of Chris Eley)

of the south-east along with the railway it created, gave the town a share in a population shift to the UK's southern section. This drift, combined with vigorous town policy, saw light manufacturing plants take on the role once occupied by the railway. These factors brought prosperity and striking retail growth.

Into such vigour, the then borough of Swindon undertook to develop a large retail shopping centre slap bang in the middle of the town. One that would 'play a part in and revitalise rather than compete with, the centre of the town'. That project was the Brunel Centre and tower. Although somewhat changed from its early incarnation, it stands today as testament to that optimism and view to the future.

23. The Allied Dunbar Tri-centre (later Zurich): 1980s

Lord Joel Joffe (12 May 1932 – 18 June 2017), known for his role in the Nelson Mandela Rivonia Trial, co-founded Hambro Life Assurance. Hambro Life later morphed into Allied Dunbar, a large British life assurance group based in Swindon. Joel Joffe had a huge influence on Swindon, not least of which was his company and the Allied Dunbar Tri-centre. It being 'one which has landmark quality or contributes to the character of an area or the quality of recognisable spaces, by virtue of its function, location, age, design or features'. Yep – the Swindon Borough Council list again.

Comprising three discrete buildings it's no surprise why they called this office development the Tri-Centre. Constructed in the 1980s, the Tri-Centre was seen as a case study in contribution to public open spaces and walking routes.

The three buildings frame a large public open space with a café in its centre that links the town, in a natural walking route, with the railway and bus station to one side and behind it. Its ground-floor colonnades provide both visual interest and some protection from inclement weather – useful when you're traversing between the bus station and the underpass into The Parade. What I remember about the colonnade when walking into town from Polaris House over on North Star was the handy shelter from the elements, if not the cold, it provided for Zurich staff grabbing a shivery smoke.

At the time of writing, though not as expansive as they once were, Zurich remains in Tri-centre One. Renamed No. 3 Newbridge Square, Tri-centre 3 houses Fig Offices – serviced offices, meeting rooms and co-working spaces. Tri-centre 2 is a home to digital process solutions business Capita.

We can argue that the Tri-centre, along with the likes of the Nationwide HQ on Pipers Way, symbolise a shift from Swindon as heavy industry town to Swindon as a commerce centre.

An early Tri-centre. (Courtesy of Carter Collectables)

Above: The square between the buildings. (Courtesy of Chris Eley)

Left: A section of the Tri-centre. (Courtesy of Chris Eley)

Rodbourne

24. Rodbourne Manor: Sixteenth Century

With a busy industrial estate, once home to the town's second largest employer, Plessey, the areas of Rodbourne Cheney and Cheney Manor played an important part in Swindon's industrial history. But it has its own history too – as a hamlet complete with a lord of the manor and thirteenth-century listed buildings.

Swallowed by New Swindon, and now a suburb of the town only 1.4 km away, the erstwhile village of Rodbourne Cheney appears in the Domesday Book as 'Redbourne' – coming from the brook that runs near St Mary's Church. Over a thousand years ago this brook bore the name Hreod Burna (Saxon) or Reedy Bourne ('burn'/'brook'). Due to a range of architectural, historical and environmental factors this historical area became a designated conservation area in 1990.

In 1242 one Ralph le Chanu/Chanue held the manor of Rodbourne. Johannes Channeau, the first named vicar of St Mary's at Rodbourne, recorded this fact for our delectation. It's from Chanu that we get the second half of the village's name – and the distinguishing factor between it and the Rodbourne near Malmesbury. All of which brings us to Rodbourne Manor, a rare survivor in the middle of Swindon's spread. Here is a bit of old England, tucked away in a quiet, secluded corner of Cheney Manor Road.

Rodbourne Manour. (Courtesy of Robert Slade)

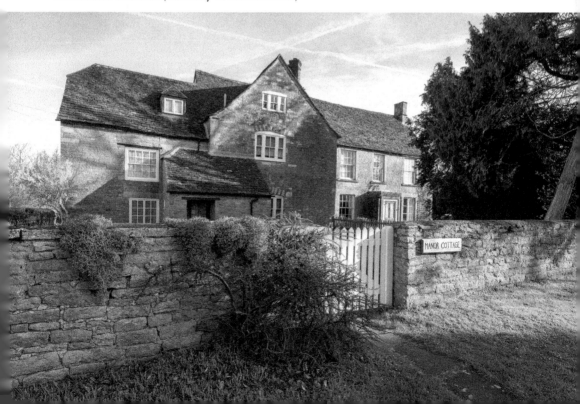

Rodbourne Manour. (Courtesy of Robert Slade)

Built in the sixteenth century, with coarse Swindon stone, and probably on the site of an older building, this is a stone-tiled, Grade II* listed building – the second oldest house in Swindon, though it's now two houses. Bringing to mind a well-known Kink's song, 'The Village Green Preservation Society', there's even a small village green in front of it where the hunt once met and where, it's alleged, were stocks.

The core of the two-storey manor is late sixteenth century, though with various additions across the centuries, perhaps the most recent being a twentieth-century lean-to porch.

The 1895 edition of Kelly's directory records one Henry C. Warry as living at the manor house. A more recent occupant of the house, until 1977, was Mrs Knapp – the last mayor of Swindon before it became the borough of Thamesdown.

25. The Pattern Store, Rodbourne Road: 1897

Surmounted by huge water tanks, the Pattern Store dominates the Rodbourne Road cutting. This fireproof building – to protect the patterns themselves, one supposes – is a 'rare survival of a purpose-built pattern store, constructed by and for the Great Western Railway Works in 1897'. It has group value with the adjacent Grade II listed engine turntable and the other listed buildings of the former GWR Works to the east of Rodbourne Road. Hence its Grade II listing.

Above: The Pattern Store,
Rodbourne Road side. (Courtesy
of Martin Parry)

Right: The Pattern Store and
engine turntable. (Courtesy of
Martin Parry)

On 22 July 1896, the GWR directors agreed on a need for a new pattern store at a cost of £4,000. The old pattern stores were full to bursting and many patterns were being stored outdoors under sheeting.

The directors decided that GWR workers would construct the new store using materials from its own stores, under the supervision of William Dean, locomotive and carriage superintendent for the works.

The Pattern Store has the distinction of being the first building erected on land to the west of Rodbourne Road. The GWR acquired the site in 1884 and had, up to this development, used it to store redundant broad-gauge locomotives.

Following the 1948 railway nationalisation, the works came under the umbrella of British Rail Engineering. That marked the beginning of Swindon slipping into the sidings before closure in 1986.

Over the years the Pattern Store has done duty as a pub/bar (The Pattern Store Bar) and an Italian restaurant. As I write, the building is taking on new life as the Pattern Church, part of the diocese of Bristol. Local media reports some division of opinion about this move. A spokesperson for the church said, 'Whilst the building is being opened as a church, it will also be able to provide open multi-functional spaces for wider community use and this will allow the building to be enjoyed once again by the people of the town.'

I find something pleasing and appropriate in a building that was once part of God's wonderful railway, that cathedral to engineering, becoming a church.

26. The GWR Works (now the McArthur Glen Outlet Village): *c.* 1843

Put all stories of dropping of stones and tossing of sandwiches out of your mind now. The most likely deciding factors leading to Gooch and Brunel's decision to pass their railway where they did are its midway point between GWR terminals and the area's topography. Not forgetting the inevitable Nimbyism of the local aristocracy. A railway near them, they did not want.

Of course, the works isn't comprised of one solitary building but a collection of workshops: The Long Shop, A Shop, O Shop, the carriage works and so on. Most of them are now incorporated into Swindon's McArthur Glen Outlet Village – a modern industry grown phoenix-like from the ashes of that which once clamoured and clanged within those walls.

From 1836, Brunel's locomotives came from a range of manufacturers. By 1837, he recruited Daniel Gooch to rectify the repair burden of this mixed bag of locomotives: the GWR needed a central repair works. Cutting a long story short, 25 February 1841 saw the GWR directors authorise the establishment of the Swindon Works.

Construction began straightaway and, on 2 January 1843, the repair works became operational.

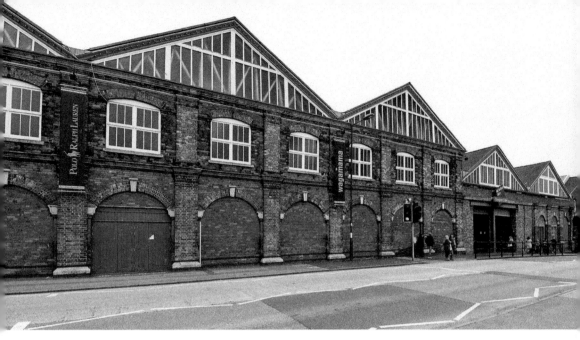

Above: GWR Works main entrance, Rodbourne Road. (Courtesy of Martin Parry)

Right: The Works' hooter. (Courtesy of Martin Parry)

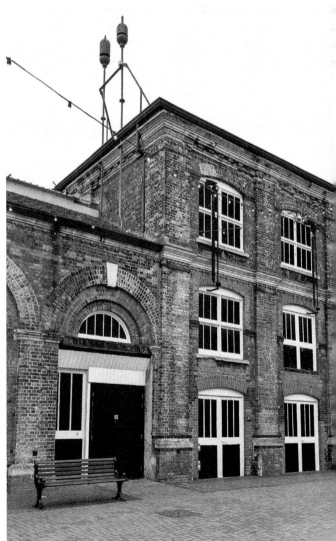

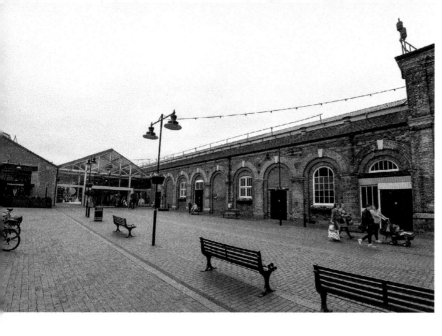

Food court entrance. (Courtesy of Martin Parry)

Using contract labour, the year 1841 saw completion of the first building – the locomotive repair shed. The necessary machinery went in it in 1842. Only 200 strong in the first instance, the workforce began repairs in 1843. The men constructed the first new locomotive, 'Premier', in less than two weeks in 1846. Later it was renamed 'Great Western'.

By 1851 the works employed over 2,000 men and produced around one locomotive per week. The year 1861 saw the installation of a rolling mill for manufacturing rail, attracting workers from South Wales and the establishment of the Cambria Place settlement.

Expansion soon became the name of the game. From 1850, in addition to locomotive building, standardised goods wagons were produced. Then, in 1867, Swindon became the central workshop for constructing carriages and wagons. In 1920 the huge 'A Shop' came to completion. It covered 11.25 acres and arguably heralded the works' heyday, employing over 14,000 people at that time.

27. St Mark's Church, Park Lane: 1845

In a bold claim, Sir John Betjeman described St Mark's, dedicated on the feast of St Mark on 25 April 1845, as the most loved church in England.

Swindon has three 'railway churches', built to serve the spiritual needs of the GWR's ever-expanding workforce. St Augustine's (in Even Swindon, aka Rodbourne) was consecrated in 1908 and St Barnabas' in Gorse Hill in 1885. Sometime before both of those, though, came St Mark's. George Gilbert Scott designed this, the first railway church in the Decorated Gothic style. He later went on to design the Foreign Office, St Pancras station and hotel, Edinburgh's St Mary's Cathedral, the Albert Memorial and Swindon's Christ Church, the Lady on the Hill – the hill of Old Swindon, that is.

Above: Looking across the GWR park to St Mark's. (Courtesy of Chris Eley)

Right: St Mark's Church. (Courtesy of Chris Eley)

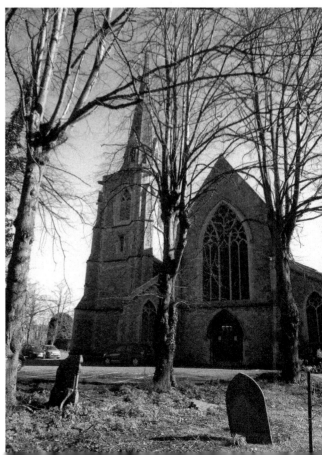

Main entrance to St Mark's Church. (Courtesy of Chris Eley)

Following the establishment of the Railway Village, the need for a church became urgent. Before 1845, Swindon's one and only parish church, Holy Rood, lay in the heart of Old Swindon (now Old Town) over a mile away from the new settlement. Hence St Mark's came in 1845 and, the following year, the establishment of the Swindon New Town District Chapelry from Old Swindon's ancient parish.

Following the railway's arrival, the population in the two Swindons boomed. Yet, even before that, the ancient Holy Rood Chapel's congregation was bursting out of the doors. Furthermore, it wasn't structurally sound, which is why 1851 saw Christ Church built on Cricklade Street and Holy Rood closed and dismantled.

In 1855, St Mark's bought a new organ for the church. The Mechanics' Institution bought the old one for their theatre and put it to use in the many musical entertainments staged there.

In 1985, marking the 150th anniversary of Swindon's great, Great Western Works, and in commemoration of years of co-operation between church and works, British Rail Engineering made a hanging pyx* from an old brass Victorian sanctuary lamp. A commemoration somewhat marred by British Rail announcing, in that same year, the complete closure of the Swindon Works, with the loss of 2,300 jobs. A devastating blow to say the least.

*A pyx is a small, round container used to carry the consecrated host (or Eucharist) to the sick or anyone unable to attend church for Holy Communion.

28. The Dolphin, Rodbourne Road: 1872–73

Picture a time when Rodbourne Road had little or none of the speculative development that came later. A time when there were no houses spreading northwards between the Rodbourne Lane railway crossing and the old village of Rodbourne Cheney. The great GWR Works was there, of course, but very little else.

On the face of it then, the decision by Arkell's Brewery, in 1872–73, to build The Dolphin public house in splendid isolation on the west side of the road appears an odd one. As a public house, it had no local trade to rely on. It took a ten-year period for the additions of Linslade Street, Guppy Street and Jennings Street to arrive.

Yet, Arkell's showed their nous in opening from the outset not only a small beerhouse, but an inn. They saw a need to accommodate visitors to the GWR Works and, it's reasonable to assume, foresaw the housing development that eventually followed. In proximity to the works and placed to take advantage of the Rodbourne Road entrance opposite, The Dolphin lay in perfect position to refresh thirsty railway men coming off their shift. Indeed, in his *The Swindon Book*, Mark Child states that Arkell's intended The Dolphin as a place of importance from the outset. In what later became the car park, an 'enclosed quoit ground with lawn adjoining' was laid out. It seems this area saw further development as a pleasure

The Dolphin. (Courtesy of Chris Eley)

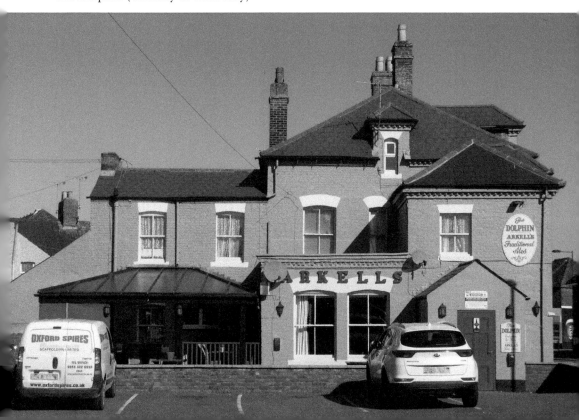

garden, to which you went for weekly outdoor pleasure dances. The twinkle toed of Rodbourne enjoyed these events until the First World War.

Robert Bishop was the first innkeeper here. From time to time the brewery granted him special licences, allowing him to open at 4 a.m. on railway 'Trip' days. 'Trip' being a huge social event when the town's railway employees and their families left, en masse, to go on holiday.

Bishop departed The Dolphin in 1879 to run the Great Western Hotel – another important place of refreshment to the GWR.

Left: The mural on The Dolphin. (Courtesy of Chris Eley)

Below: Corner view of The Dolphin. (Courtesy of Chris Eley)

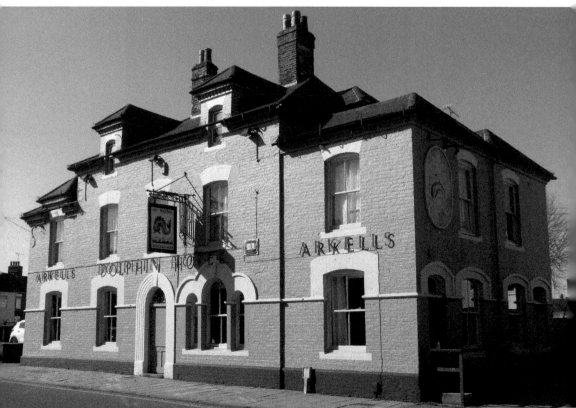

Pinehurst

29. The Pinehurst Estate: 1918 to the Second World War

The Pinehurst estate was Swindon's first planned council estate, one that 'serves as a reminder and record of the gradual development of the settlement in which it stands...' ('Buildings of Significant Local Interest' by Swindon Borough Council.) This is another cheat in that it's lots of buildings, not only one, but again is too significant to ignore.

Men and their families poured in to New Swindon from all over the country to avail themselves of the opportunities afforded to them by the GWR Works. Speculative developers seized their opportunity and new housing spread to its left, right and centre to accommodate them. As a result, New Swindon grew like Topsy from its first model village incarnation. Then came Pinehurst, a designed estate built to relieve the post-First World War housing shortage.

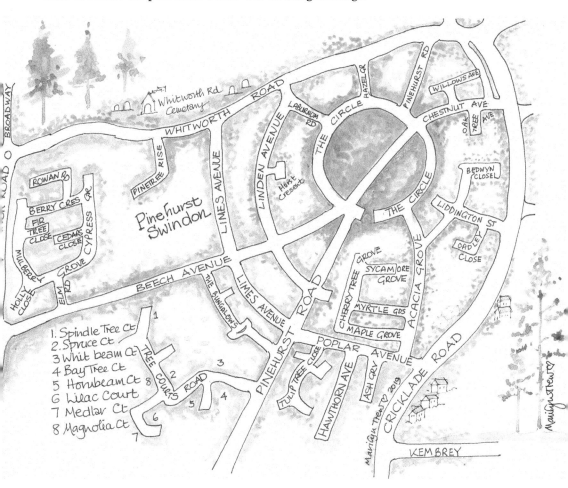

Map of Pinehurst Circle by Marilyn Trew.

Some of the housing on the Circle. (Courtesy of Chris Eley)

Designed by Sir Raymond Unwin, the Pinehurst estate utilised farmland roughly 3 miles north of the town centre – on an area once reserved for a smallpox hospital to one side and an isolation hospital to the other.

The years between 1918 and the start of the Second World War saw the first phase of the estate's development with the construction of large, sturdy, red-brick semi-detached houses. Swindon built 932 council houses during this time and almost all of them were on the Pinehurst estate, with its layout and streets named after trees.

Gorse Hill

30. St Barnabas Church, Gorse Hill: 1885

St Barnabas, with its half-finished tower is, along with St Mark's at Rodbourne, another of the 'railway churches' built to ensure that the GWR's employees had adequate provision for their spiritual succour.

An Anglican parish church built by J. P. Seddon, it achieved its Grade II listing in 1990 for special architectural or historic interest. St Barnabas sits where two of Swindon's old roads – Ferndale and Cricklade – meet. It's a mere fifteen-minute walk from the town centre.

The notable thing about St Barnabas is its paintings depicting Swindon as the 'New Jerusalem'.

Encouraged by Revd Basil Minchin, Revd John Perrett, sometime Rector of Stanton Fitzwarren, near Swindon, created the paintings. They are his 'thank you' offering for recovery to health. Prepared with white lead and canvas for the work, he painted them in 1946, 1947 and 1948 – *Ad Maiorum Del Gloriam* (To the Greater Glory of God).

You can find a full description of the paintings at www.wiltshire-opc.org.uk. There's too much to give a full description here, but to give you a flavour:

The men of the parish, with the help of God's grace, symbolized by a powerful angel, raise a factory from the dark world of greed towards the peace of God's nature and

offer it. The women of the parish offer their children. The young men offer a railway engine … They reach Gorse Hill and its gas works; they are supported by the prayers of the churches they leave behind, and raise a fiery cross. Swindon is seen in the background with the Railway Works and the green downs behind.

A glorious thing, and a thing of glory. Amen to that.

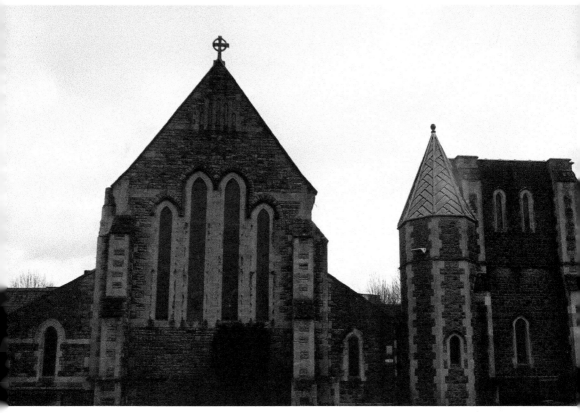

Above and right: St Barnabas.

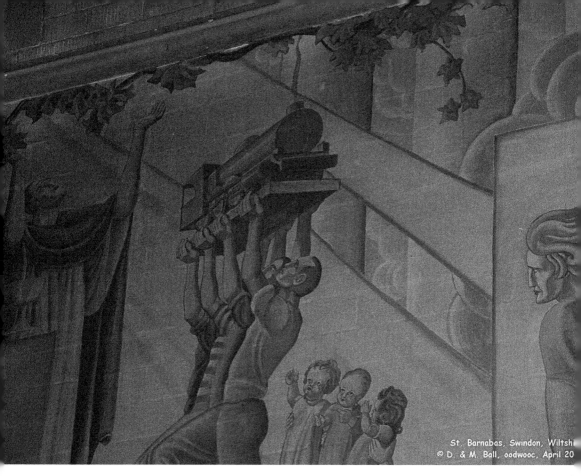

Section of the mural. (Courtesy of D. and M. Ball)

Stratton St Margaret and Upper Stratton

31. Arkell's Brewery, Kingsdown, Hyde Road: 1861

Back in the 1870s, when both the GWR Works and the numbers of those toiling inside it expanded fast, Swindon had something like one pub for every sixty-five bodies. I remember something similar from my Derbyshire village, where almost all the men worked in the mines – an equally thirst-building occupation as building locomotives. There, too, we had many pubs for one small village, though not our own breweries. Yet nineteenth-century Swindon boasted at least a dozen. The buildings that some of them brewed from are still with us in other guises. I've opted to feature Arkell's here, but not because it was Swindon's first brewery. So far as I've gleaned from my reading, the no-longer-shining Star Brewery holds the distinction of being among Swindon's first. It first fermented in eighteenth-century Stratton while the Arkell family still worked the land. But of them all Arkell's still stands, still brews and still refreshes. It's now Swindon's oldest extant business.

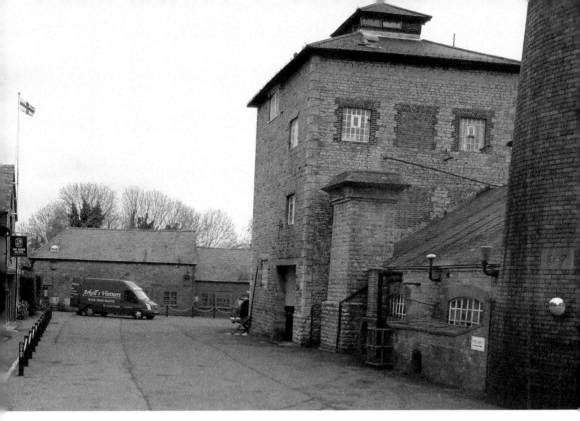

Above: Arkell's Brewery. (Courtesy of Royston Cartwright)

Below left: Arkell's Brewery's chimney. (Courtesy of Royston Cartwright)

Below right: The Kingsdown Steam Brewery.

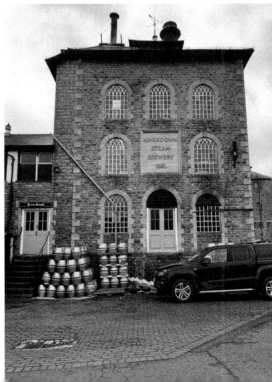

The 'Our History' section of the Arkell's website states: 'Anyone visiting Arkell's Brewery for the first time could be excused for thinking they have walked straight into a time machine.' They're not wrong. The brewery buildings do indeed seem untouched by the passing years. Only the presence of vans and aluminium barrels hint at the modern brewing enterprise within the historic buildings.

I've already mentioned that the Arkell family started out as farmers. John Arkell, the brewery's founder, emigrated to the New World in his youth, taking with him a brave group of locals seeking respite from the grim grind of agricultural life. They went to Canada, establishing a community bearing the Arkell name. Yet John's fiancée yearned for England. So, love brought him back to Stratton St Margaret – not then part of Swindon – and barley growing.

Now John Arkell's story buffers that of the GWR. He realised the potential market for selling beer just as Brunel's works were steaming ahead. The population exploded – and it was thirsty. Thus, in 1861 a new Arkell's steam brewery burst into production at Upper Stratton. That it's still brewing is quart-pot-raising worthy.

32. Boundary House, Beechcroft Road: 1894

An allegation abounds that this curious building with its varied history got its name for its status as the last house at which dues and rates were payable to Highworth rather than Swindon. Because, before the railway came, Highworth was a larger and more important town. This story isn't fully substantiated, but remains the received wisdom. Built by the King family, it's thought the house is a replica of the owner's Bayswater home.

Early twentieth-century photographs show large carriage wheels in the building's workshop annexe. Accompanying descriptions described the annexe as the 'Napoleon Carriage, Cycle and Motor Works of Messers King and Co'. So, the King family it seems were embracing the inevitable progression to motor cars as the favoured form of transport.

In 1917, Charles Henry King died of tetanus and the building went to auction as a 'Gentleman's Residence'. Beyond that period, anecdotal evidence suggests that the building became a maternity home in the latter part of the First World War.

An interesting trivia note that I read in a history of the King family: in the early 1990s a cwt (hundredweight – 50.8 kg) of coal cost 8*d*. Delivery by the GWR (who supplied coal to Swindon as well as for its own use) was a halfpenny on the Stratton Cross side of the building and one whole penny on the other – the postcode lottery even then!

In 1985, with the help of a council grant, the then owners, Stratton Auto Mart, renovated the derelict building and the sales-cum-workshop annexe and converted it into six self-contained flats. And, to my knowledge, that usage continues.

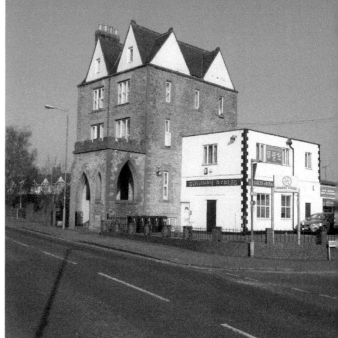

Above left and right: Boundary House. (Courtesy of Chris Eley)

Eldene

33. The Crumpled Horn: 1975

> This is the cow with the crumpled horn,
> That toss'd the dog,
> That worried the cat,
> That kill'd the rat,
> That ate the malt,
> That lay in the house that Jack built.

Thomas Turner's Drove Road catalogue houses aren't the only Swindon structures with a touch of the whimsy about them. Listed in 2018, the Crumpled Horn in Eldene, in Swindon's eastern suburbs, is one of five quirky English public houses now with listed building status. Situated off Dorcan Way, its cultural status is now recognised with a Grade II listing.

The brewery Watney-Mann commissioned this estate pub and had it designed by themed-pub specialist Roy Wilson-Smith – a leading exponent of kitsch architecture. It served its first pint in 1975 and is the only survivor of a group of Watney-Mann pubs designed around the theme of the nursery rhyme 'This is the House that Jack Built'. Historic England describe it thus:

> Almost unaltered, it is a good example of Wilson-Smith's innovative and eccentric style. In common with all the pubs he designed, it illustrates his interest

Above and left: The Crumpled Horn. (Courtesy of Royston Cartwright)

in multi-level plans. Built as an irregular eight-sided polygon on a sloping site, the pub contains a single bar area which takes the unusual plan form of a spiralling 'nautilus shell'. The shape creates intimate drinking spaces on different levels, as well as reflecting the 'horn' of the pub's name.

In his announcement of the new heritage listings, Duncan Wilson, chief executive of Historic England, commented that pubs sprang up in their thousands from the mid-1950s, becoming the hub of communities. The Crumpled Horn and the others listed alongside it are the best surviving examples of a building type now embedded in English culture. Heritage inspectors observed that the eight-sided Crumpled Horn pub, with its asymmetrical roof and ramshackle brickwork, has an air of eccentric craftsmanship.

From the 1950s to the 1970s, Watneys were no different to any commercial organisation, in that they both reacted to, and attempted to lead, the market. Sometimes their themed pubs showed great innovation, while others plumbed the depths of bad taste. As to which category this one fits in – you decide. As for me, I rather like it.

South Marston

34. Dryden Cottage and Ranikhet: 1873 and 1921

When thinking of buildings associated with Alfred Williams, Swindon's 'Hammerman' poet, it's not possible to choose only one. William's lived his entire life (war service aside) contained in one tiny area of South Marston. Here there are four houses, each a mere stone's throw from the others, that saw Alfred Williams hatched, matched and despatched. In a modern world of easy movement this seems astonishing, but less so when you consider that in Williams' lifetime you had two transport options for transport: your feet or a bike. There are four houses with links to Williams: Cambria Cottage, his birthplace; Rose Cottage, his home from the age of five or six; Dryden Cottage, where he spent much of his married life and did much of his writing; and Ranikhet, where he died. For the purposes of this book, I'll focus on two. The two that had the most resonance for the adult Alfred.

Dryden Cottage. (Courtesy of Graham Carter)

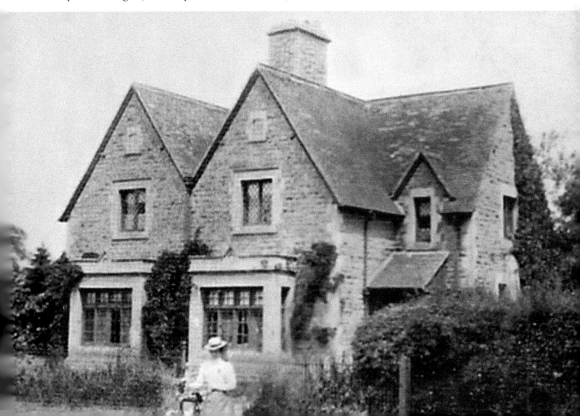

Ranikhet. (Courtesy of Graham Carter)

Dryden Cottage

Alfred and Mary Peck rented one half of this semi-detached building after they married on 21 October 1903. This house sits on land close to The Hook, on Thornhill Road, across from the former South Marston Post Office. There's a stone in the wall of the cottage bearing the initials 'AB' – Alfred Bell, the effective lord of the manor from the 1850s. The house next door bears a stone showing its construction date as 1873.

In 1919, Alfred and Mary received the news that they had to leave Dryden Cottage because of a change of ownership. They remained there until the completion of Ranikhet in 1921.

Ranikhet

Mary and Alfred quite literally built this house themselves. They did it using stone reclaimed from Mark Titcombe's former cottage in the village and from an abandoned lock on a stretch of the Wilts & Berks Canal, close to the main Swindon–Oxford road.

Standing on The Hook, on which Cambria Cottage and Rose Cottage also stand, Alfred and Mary named Ranikhet after the Indian Hill station where Alfred had a First World War posting with the Royal Field Artillery.

Alfred Williams died in Ranikhet in 1930 and Mary followed him to the grave a mere seven weeks later. Since their time, the house has been extended at the front and rear.

Coate

35. The Coate Farmhouse (aka the Richard Jefferies Museum)

Located at Coate between the Swindon to Marlborough road and Coate Water Country Park, the Richard Jefferies Museum and garden is a tranquil delight. The mulberry tree that Jefferies knew as a boy still stands and still bears fruit.

Mike Pringle and the team running the museum have wrought wonders with it – increasing visitor numbers by a dramatic amount. Sitting there on a sunny, summer Sunday afternoon with a scone and a cuppa is a most agreeable activity.

Built in the 1600s as a small thatched cottage with a dairy, the Coate farmhouse, celebrating the naturalist and writer Richard Jefferies, became Grade II listed in 1986. The seventeenth-century farmhouse with thatched roof has an adjoining nineteenth-century house – and that's the part that forms the museum.

The house hasn't always been the home of the Jefferies family, though. After being in the Herring family for generations, the great-grandfather of the Richard Jefferies we know – also named Richard – bought the 36-acre dairy farm in 1800 from Thomas Herring for £1,100.

By 1825, Jefferies' farm had passed to John Jefferies – grandfather of our man. He worked in London for a printer and publisher, thus wasn't keen to return to Coate. Yet, with reluctance, he and his wife did so, and took over running the family milling and bakery business. His succulent specialties earned him the less-than-flattering nickname 'Mr Lardy Cake'.

Our Richard Jefferies came into the world at the Coate farmhouse, as the second of five children, on 6 November 1848.

James Luckett (the writer's father) inherited Coate Farm, where he'd worked for twenty-four years. But the bequest had strings. Legacies of £1,300 had to go

Coate farmhouse.

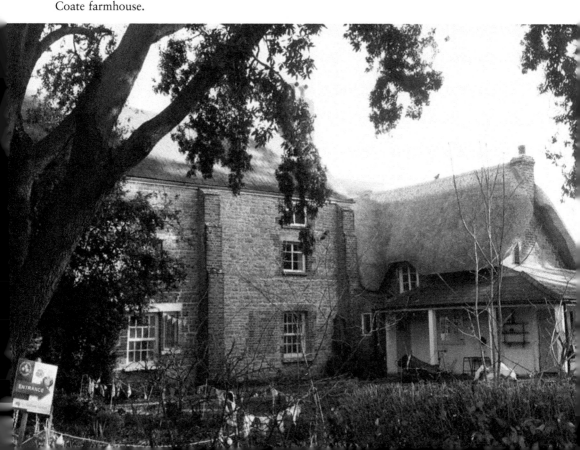

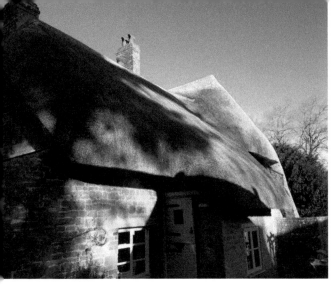

RJ House.

Showing thatch.

to Jefferies' sisters. Imagine the burden. Indeed, it was too big of one. Poor James Luckett's luck ran out, forcing him to sell his home in 1877.

A succession of different owners followed until Swindon Corporation paid around £2,000 for the farm in 1926. The museum first opened in the 1960s.

36. Drove Road Villas: 1871 and 1879

Designated in SBC's ever so lovely 'Buildings of Significant Local Interest' document as one 'which is the work of a particular architect, builder or developer of local, regional or national note', there's a touch of the fairy tale about these houses.

Known as 'pottery cottages' back in the day, and now colloquially known as the 'catalogue houses', the gabled houses that comprise Nos 148–150 Drove Road

Front Elevation.

Ground Plan.

Plans of the villas.

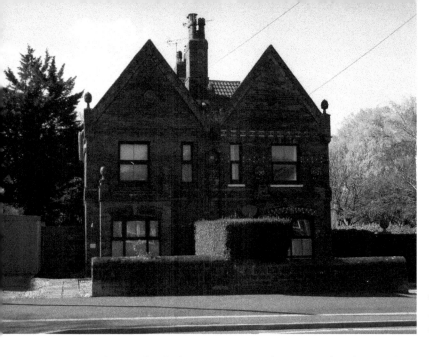

The villas today. (Courtesy of Chris Eley)

were the work of Thomas Turner. The reason for their nickname being that they do what they say on the bricks. Turner designed these houses to advertise his wares by displaying every tile and brick, and each moulding and finial he made in his brick works, the Swindon Tile and Pottery Works. The whole lot was topped off with terracotta acorns, rosettes and crests.

Turner's tile and pottery works lay behind the cottages in what is now the Queen's Park ornamental garden, constructed around the site of his works and clay pits. In addition, there's a detached cottage beside the Queen's Park eastern entrance, which was built by Turner as the works' manager's house.

37. The Technical College, Burkhardt Hall: 1897

The Historic England website describes the old technical college as being 'Flemish-Baroque style built by Messrs Long and Sons of Bath, to a design by the architect and surveyor Thomas Ball Silcock (1854–1924)'.

In 1891, following the Technical Instruction Act of 1889, the Swindon New Town Urban District Council set up the Swindon and North Wiltshire Technical Instruction Committee. Though Swindon had a school board from 1877, the Mechanics' Institution remained the providers of adult education. Its board instigated talks with Wiltshire's education committee apropos establishing a permanent building for technical instruction in Swindon, with Burkhardt Hall being the result. The three-storey building opened its doors on 27 January 1897 on land donated by Major Rolleston.

The year 1902 saw the abolition of the school board and the formation of an education committee. This was under the auspices of Swindon Borough Council, who adopted the Education Act. At this point the Mechanics' Institution ended its

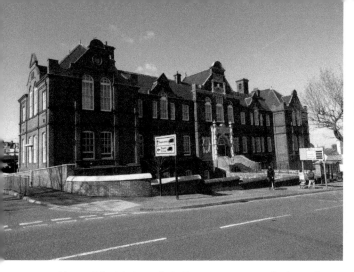

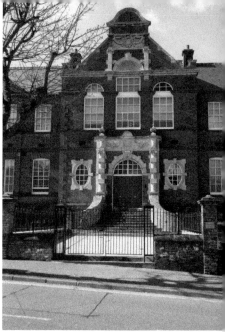

Above: The Technical College. (Courtesy of Chris Eley)

Right: Front section of the Technical College. (Courtesy of Chris Eley)

involvement in technical education. Come 1926, the refurbished and reorganised technical college reopened its doors as a further education college – The College. Then came years of extensions on the Regent Circus site, until in 2006, closure and transfer of everything to a new campus on North Star.

What follows is an all-too-common Swindon story of neglect and decay, with the building's saviour from the ubiquitous wrecking ball coming in the form of Historic England's Grade II* listing.

Amid cries that Burkhardt Hall would serve well as a civic building or museum – cries not without merit – it's at least now preserved and in use. Which is a darn sight more than we can say for the Mechanics' Institution.

Now a sensitive flat conversion, the building retains the commemorative scroll to headmaster George Henry Burkhardt in the corridor. The reinstated entrance hall features a large memorial window, 'A Special Time and Place'. It comprises a *trompe l'œil*-style open window and a welcoming bright poppy field leading to Swindon's nearest ancient icon – the Hackpen White Horse. The poppies commemorate the lives of the forty-five students who died in the Second World War.

Old Town

38. The Bell Inn, High Street: 1515

Every settlement in the land had and has its share of public houses. Records show that the 300 residents of seventeenth-century Old Swindon had a choice of nine hostelries in which to slake their thirsts. Those drovers were evidently a thirsty lot.

The Bell Inn on High Street in Old Town bears the reputation of being Swindon's oldest licensed premises. 'Establyshed in ye reign of Kyng Henry VIII AD 1515,' proclaims the legend across the doorway. Yet that's a mite misleading. The front

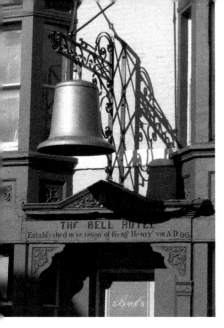

Above: The Bell Inn. (Courtesy of Chris Eley)

Left: The bell over The Bell! (Courtesy of Chris Eley)

elevation of the building we see today is nineteenth century. Though, before the Bell Inn donged its first 'last orders' call, it existed as an inn called The Lapwinge – and that's the sixteenth-century link, with extant ancient cellars, to which we can raise a tankard.

According to Mark Child's *The Swindon Book*, that early hostelry established by Flemish wine and spirit merchants originated in 1515. Lord of the manor Richard Goddard conveyed this earlier incarnation to Samuel Haggard in 1649. It might have been then when the inn got its new name – it appears as the sign of the Bell in Swindon in a 1666 document.

In the early nineteenth century, Charles Rose ran the place both as an inn and posting house. Now, if Royal Mail threw in a pint with a postage stamp our post offices might be thriving yet.

Then, when coach and horse travel ruled the roads, such as they were, The Bell Inn served as a stop-off point for the *York House* passenger coach running between Bath and Oxford. It was also a terminus for the post coach between Swindon and London.

Refronted in the late 1870s, the building is three-storeyed with three bays. There's a central canopied entrance between two bays and a carriage entrance through the third. Where there used to be a canopy spanning the pavement from the front door there now hangs a sizeable gilded bell.

Many Swindonians have fond memories of folk music evenings there and of seeing the 1960s modern beat combo The Strawbs perform there.

39. Vilett's House, No. 42 Cricklade Street: 1729

Another house one can't ignore when narrating Swindon via some of its buildings is this one. The poet John Betjeman referred to it thus: 'The first architecture to appear in Swindon, that is to say the first conscious designing of a façade … is

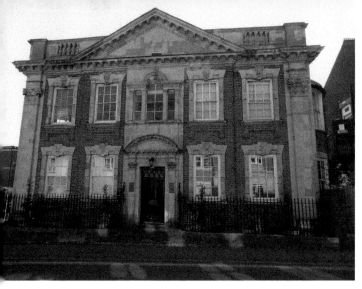

Above left: Vilett's House. (Courtesy of Chris Eley)

Above right: Detail on Vilett's House. (Courtesy of Chris Eley)

one of the most distinguished town houses in Wiltshire.' Indeed, the front of the house bears a plaque proclaiming that very thing. That's not, it seems, the house's only accolade. Mark Child in *The Swindon Book* observes that Niklaus Pevsner called it 'the best house in Swindon by far'. And who are we to argue with such authorities? I'm not that brave.

First listed in 1951 and now Grade II* listed, the façade of Villett's House is Flemish brickwork with ashlar limestone dressings.

The Harding family built the main part of the property. The name Villett's comes from the family of Swindon aristocracy who owned it after 1770 – Thomas Vilett and his wife, Mary Goddard.

The house sits on the site of a one-time cottage and the White Horse Inn. Confirming its use as an inn, the house features extensive brick-vaulted cellars. Used neither for coal or wine, it's thought this network of passages once ran to other parts of Old Swindon. They're often cited as evidence of Swindon's smuggling activities. William Morris, founder of the *Swindon Advertiser*, held an unshakeable conviction that people used Swindon's cellars and tunnels for smuggling dating back to Harding's occupancy or even before. Despite smuggling being associated with coastal communities and the wrecking of ships, and despite it being millennia since Swindon was underwater, Morris told eighteenth-century tales of villages 'not very distant from Swindon' where smuggling provided a reliable source of revenue. How reliable Morris' tales were is open to debate.

40. The Goddard Arms, High Street: 1810

Hailing from Upham in the civil parish of Aldbourne, Wiltshire, one Thomas Goddard acquired the manor of Swindon (what is now Old Town) from the Crown in 1563.

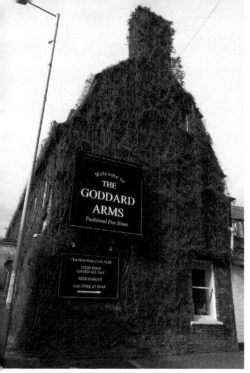

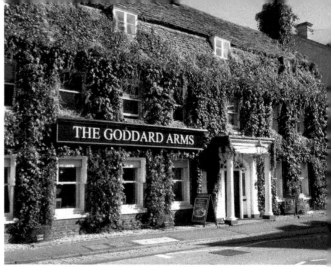

Above: Front of Goddard Arms.

Left: A side view. (Courtesy of Chris Eley)

He also, in 1621, purchased The Crowne Inn. His estate – Lawn – lay a few yards away down the High Street.

Built at the point where the High Street meets Cricklade Street, The Crowne was a small, thatched alehouse that suffered an eighteenth-century conflagration. With livestock trading expanding, a larger, meatier coaching inn was deemed more suitable for the town's growing economy. Thus, in 1810 the new inn, renamed to honour the Goddard family, opened for business – of all kinds.

During the 1800s, The Goddard Arms was swift in becoming the most important hostelry in the town. Here the court met and the magistrates' and county courts took place in the oak-panelled Pleydell Room (it was given that name later). Most of the traders' associations and public societies of the period held their meetings there. In addition, the inn served as a scheduled stop for the passenger coach *The Plough* on its regular Monday, Wednesday and Friday runs to Southampton.

In 1850, the hostelry had a large assembly hall added to the rear for balls, public concerts and other entertainments. Further, at around the same time, William Dore established a livestock sale yard at the rear. The Goddard Arms then served as more than a mere public house. For more than a century it was the focus of Swindon's commercial activities.

As if pig markets, coaches and county courts were not enough of a rich history, the inn has seen its share of drama and tragedy. In 1819, hangman Jack Ketch and the criminal due to die at his hand the next day spent the night there. Then, in 1863, a shocked boots boy discovered the body of a newborn baby in a lumber room. The body had lain there so long that neither the cause of death nor the baby's sex were discernible.

41. Apsley House, Bath Road: 1830–40

Apsley House is better known today as Swindon Museum and Art Gallery. Yet the house has stories to tell of its time before becoming home to Swindon's extensive local collections and impressive modern art collection. From its 1941 establishment via an impressive donation of twenty-one works by a local businessman, H. J. P. Bomford, the collection now comprises around 600 works of art and 300 studio ceramics.

Built in the 1830s, the house's first leaseholder was Charles James Fox Axford, and its next occupant a respected surgeon, Frederick H. Morris. Now for a tale of two Ts. In 1862, Morris sold the house to one Richard Tarrant, who had a wholesale/retail business dealing mainly in coal, coke, salt, slate and straw. At the same time, and also in Bath Road, John Toomer operated a rival business. Toomer had a great advantage over Tarrant: he supplied the GWR, whose expansion kept his business on track. Indeed, the Toomer business rolls on with branches in both Swindon and Cirencester. In 1870, Toomer bought Apsley House from Tarrant and took over his yard.

The year 1930 saw Apsley House adapted to house the museum collections. The elegant staircase, decorative plasterwork and stained-glass detail in the arched windows, which always make me think of BBC's *Playschool*, are familiar features to the museum's visitors.

To display (on a rotational basis) Swindon's splendid art collection, Apsley House got a new gallery annexe in 1964, reputed to be the first purpose-built

Leaflet showing artist's impression of Apsley House and the new gallery annexe. (Courtesy of Swindon Museum and Art Gallery)

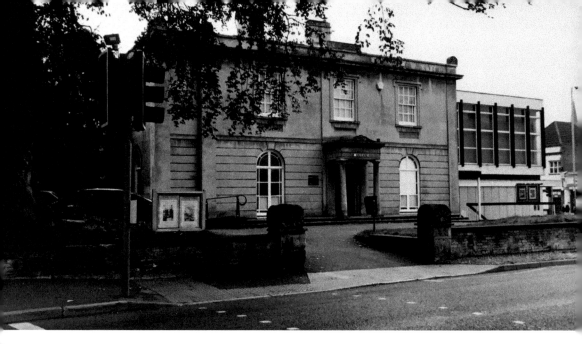

Above: Apsley
House now.

Left: The side view of
the art gallery annexe.
(Courtesy of Chris Eley)

public gallery constructed in Britain after the Second World War. Swindon's
borough architect, J. Loring Morgan, designed it. But best of all, and I love this,
the chairs and tables for the new gallery extension came from none other than
Terence Conran of Habitat fame. By 1960s standards, it seems Swindon created a
fashionable gallery.

It's a point of note and frustration to all that this *très* chic extension was
intended as a temporary measure until the town's long-promised, but never
delivered, cultural quarter Wyvern Theatre arrived.

42. Prospect Terrace: 1845–46

Prospect Terrace is an interesting one, I think. I learned of its existence only recently when visiting a part of Swindon's Old Town that I'd previously not ventured to. Not because it's in any way 'here be dragons', but because I'd had no cause to.

Once benefitting from listed building designation, this unique heritage asset in Swindon suffered demotion to conservation area status. That loss of ranking, combined with lack of knowledge about the houses, has led over time to some unfortunate and unsympathetic alterations and lack of maintenance.

Situated on the north side of Old Swindon (Old Town) and originally designated Nos 1–8 Prospect Terrace, the houses are today known as Nos 21–27 Prospect Place.

Built as a speculative venture for the burgeoning middle-class market between 1845 and 1846, the terrace comprises eight houses. Sadly, for George Major, the builder, the houses went on sale as the recession of 1847 began. In 1850, he handed the terrace to the County of Gloucester Bank to clear loans secured back in 1816. His loss turned into the bank's gain – doesn't it ever? They rented out the houses until the housing market recovered in 1862, then sold them at a profit.

Above and right: Prospect Terrace.
(Courtesy of Chris Eley)

Local architect Sampson Sage is the likely designer of the terrace, using local sandstone (possibly dug out of the site to form the cellars) in a rustic Old English style. The sandstone he fashioned into a rock-like appearance with Bath stone dressings. Later copied in the 1860s in a series of housing developments at Westcott, the terrace is the earliest example in Swindon of this architectural style.

Of course, this singular housing terrace wasn't always surrounded by a sea of red-brick housing as it is now. Prospect Place once formed part of the manor of Nethercott, Eastcott and Westlecott until, at length, it was divided into Upper Eastcott and Lower Eastcott farms and Court Knapps. Being the flattest patch of land on Swindon Hill, it got the nickname 'Bowling Green'.

43. Christ Church: 1851

Christ Church, 'the Lady on the Hill', was visited by John Betjeman, who wrote of it: 'Your peal of ten ring over then this town, Ring on my men nor ever ring them down.'

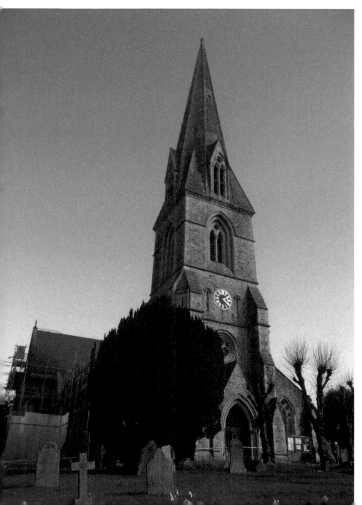

Christ Church. (Courtesy of Chris Eley)

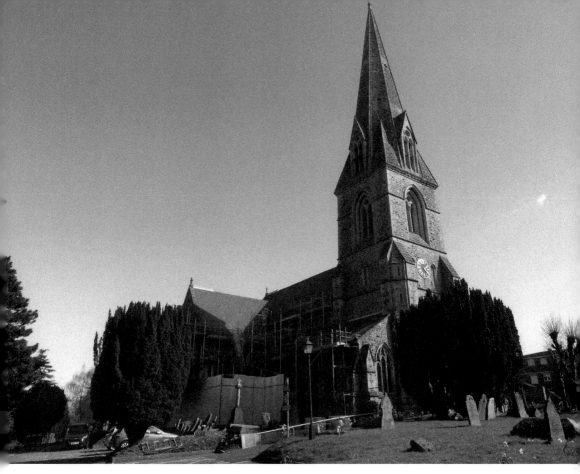

Christ Church. (Courtesy of Chris Eley)

Gilbert Scott Thomas of St Pancras and Swindon's St Mark's fame designed the Anglican Grade II listed Christ Church in 1851, in the Midland's Decorated style.

By the 1850s, Holy Rood on the Lawn estate had become woefully inadequate for Swindon's growing population, wrought by the coming of the GWR. Ambrose Goddard, Lord of the Manor of High Swindon, donated the hillside site on which Christ Church proudly stands.

The date 13 June 1850 witnessed the laying of the foundation stone for the new church in Old Swindon. Not long after 11 a.m. the bells of the old parish church, Holy Rood, pealed in announcement of a divine service of celebration. At the appointed hour the devout converged within Holy Rood's sacred walls to beseech God for his blessings upon the great work commencing that day. The vicar and reverend, Mr Mansfield, read the prayers and lessons.

It's clear from reports at the time that this occasion was quite something, with flags and banners of all colours and nations waved from the windows of Swindon's principal houses. There were flowers and laurels too, hung in garlands across the streets. Businesses suspended trading for the day, with everyone contributing to making the day one of cheerful festivity.

As with so many of the buildings in this book, the old Swindon connects with the new. In the case of Christ Church the connection comes in the form of the

south porch. In 1916, Christ Church erected this porch in memory of Henry and Harriet E. Kinneir. It features a stained-glass window depicting the Great Western Railway coat of arms, donated by Nancy Davis in 1975.

44. The North Wilts Aerated Water Manufactory (aka the Bottle Factory), Lansdown Road: 1870

As early as 1854, Mr Edwin Robert Ing had established a chemist shop on Old Town's Wood Street. But his entrepreneurial activities didn't rest there. In 1868, Edwin Ing bought several plots of land along The Sands (now Bath Road), where he built Walton House for his family.

Come 1870, to the rear of Walton House and on the other side of the narrow lane behind it, Ing built his dual-sited North Wilts Aerated Water Manufactory. The main site of this bubbly water enterprise lay on Lansdown Road – the subject of this entry. Though both of those buildings remain today, only Walton House suffered demolition in the 1980s to make way for flats.

The factory in 2019. (Courtesy of Daniel Thuysbaert)

Though often used, the term bottle factory is a misnomer – no bottles were ever made there. In the North Wilts Aerated Water Manufactory, Ing filled bottles with water containing dissolved carbon-dioxide gas, infused under pressure from a steam engine. Thus, the 'bottling factory' fits betters. But, it's not so catchy. And at least the term 'The Bottle Factory' preserves and reminds of the building's history.

The earliest of Ing's bottles (you'll find examples in the local collection in Swindon Museum and Art Gallery and on the Swindon Bottles website) were simply marked 'E.R. ING'. Later the business marked them as 'E.R. ING & CO', along with his crossed battle axe logo. Finally, he marked their bottles with 'E.R ING & SON'.

The Ing business thrived until post-Second World War, when Ing & Son merged with William Leese's mineral water manufacturing business to form Leese Ing – nice play on words there. Leese Ing operated from Lansdown Road, the location of Ing's original factory. They traded under the brand ACE, which later came under ownership of major Swindon brewer Arkell's.

Swindon appears to be a thirsty town, given the number of such businesses. Crook, who originated in Highworth, is another. Though he started out working for Ing before branching out and purchasing the Prospect Aerated Water Co. One wonders how our man Ing felt about that – fizzing, I shouldn't wonder. And, during the 1950s, yet another one – Barker – also merged with Leese Ing & Co. Under Arkell's ACE brand they continued trading until the 1970s.

But to return to Lansdown Road. It's last use as a commercial building was as a recording studio with associated offices, operating as VideoGraphics.

Ing's elegant family home suffered demolition to make way for flats. Yet his Lansdown Road business premises has undergone sympathetic conversion into new flats. A rather neat circularity there methinks.

45. Yucca Villa, Bath Road: *c.* 1876

Falling into Swindon Town Gardens Conservation Area, Yucca Villa is one of several mid-nineteenth-century properties built there. The exception to that being Westlecot Manor, a sixteenth-century listed manor house, and some small stone-built cottages lying in the vicinity of the quarry that later became Town Gardens.

On 16 September 1868, the watch and clockmaker George Deacon attended a land auction. There he bought Plot 16 on The Sands (see also No. 44, The Bottle Factory) – the eventual location of Yucca Villa. Upon George Deacon's death in 1872, Plot 16 gets sold again and Henry Caiger, a local builder, bought and built Yucca Villa, then put it up for sale.

From that point on, many of the house's occupants buffer Swindon's history in one way or another. Cast your mind back to Wick Farm and Jonas Clark – there's a link between him and the house. Go to www.yuccavilla.com for the lowdown on that one.

Yucca Villa. (Courtesy of Noel Beauchamp)

In March 1908, Henry Joseph Hamp, the first ever borough surveyor of the newly combined Old and New Swindon, leased Yucca Villa from Charles Isaac Hibberd. Hibberd's will named Charles James Hibberd and William Eastcott Smith as trustees and executors. Interweaving with Swindon's story further, in 1882 William Smith married Jessie Emily Morris, the eldest daughter of William Morris – the founder and proprietor of the *Swindon Advertiser*.

Let's fast forward now to the period between 1954 and 1994 – a period of stability for Yucca Villa. On 11 August 1954, the house's incumbents, the Spruyt de Bays, sell the villa to Mrs Nancy Hamilton Bradley. Her husband is Lionel Bradley, the inventor of Bradstone – the reconstructed walling system that recreates the appearance of natural stone. It's reputed that the moulds for the original Bradstone came from the cut stone used to build Yucca Villa.

You'll remember Swindon's most famous town clerk? He of the tower and the shopping centre? Well, it was he that signed the land search results for this particular purchase.

One house and not many degrees of separation from a clock and jewellery business, a newspaper owner, a West Swindon farm, a town clerk and an inventor. Who knew?

46. The Swindon Advertiser Building, Nos 99 and 100 Victoria Road: 1870–99

If one is telling a story of a town through its buildings then one must make mention of its newspaper building. Albeit one recently vacated for modern premises in Dorcan.

Nos 99 and 100 Victoria Road, Swindon, are Grade II listed. Once two separate houses, they have a unified architectural Bath stone façade with classical detailing carried through to the building's interior. This building's historic interest lies in it being the premises of *The Advertiser* – the first penny paper in the country and the first steam-powered paper in Wiltshire!

One William Morris (not the wallpaper William Morris of Kelmscott Manor, but William Morris the great-grandfather of the anthropologist Desmond Morris of The Naked Ape fame) founded the *Swindon Advertiser and Monthly Record* (as it began life) in 1854.

The tentacles of the GWR reached to the newspaper's production – of course. One significant date in the paper's history is 1861. In this year the paper expanded, needing a new printing press. The slogan 'Printed by Steam Power' figured on the masthead of a boiler built by GWR apprentices to run the presses. Further recognition of the link between railway and newspaper came in 1876 when the publication date changed from Mondays, the traditional market day, to Saturdays so more GWR workers could read it.

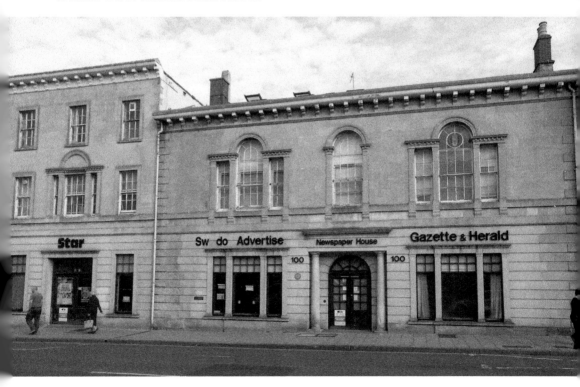

The *Swindon Advertiser* building. (Courtesy of Chris Eley)

47. Swindon Arts Centre (aka the Bradford Hall), Devizes Road: 1900

The story of Swindon Arts Centre as an entity rather than a location is a convoluted one. In its original location, in a rented Methodist Hall on Regent Street, Swindon Arts Centre was the first municipal arts centre in the United Kingdom. With support from the mayor's community fund, the centre found a champion in Harold Joliffe, chief librarian and curator of Swindon Borough Council.

Yet, when Regent Street's rental levels exceeded the council's budget, Joliffe oversaw the Arts Centre's move and official opening on another council property – Bradford Hall, Devizes Road. Previously used for the community dances, the building already had some of the technical facilities needed for a new Arts Centre.

It's named after J. E. G. Bradford, a Swindon solicitor who owned the site it stands on, together with stables and cottages demolished to make way for it. Between the end of the First World War and 1945, the hall was privately owned. During that time the hall resonated to dancing feet, being a dance venue much favoured by servicemen – in the main American forces stationed in the area during the Second World War.

Swindon Borough Council then bought the hall and continued to let it out for public dances until 1955.

Below left: The Arts Centre by night.

Below right: *Applause.*

When the building underwent internal remodelling, the sprung wooden dance floor stayed in situ and they installed 240 old cinema seats. I remember these well.

Mayor N. V. Toze, together with Llewelyn Wyn Griffith, vice chairman of the Arts Council of Great Britain, opened the new (and current) Arts Centre on 1 September 1956.

Further refurbishment in 2002, at a cost of £665,000, put in new seating. The poet Pam Ayres performed the reopening honours.

According to our man Mark Child in *The Swindon Book*, there's a ghost of a chance that the spectre of a woman in a brown dress haunts the Arts Centre. I should think she died of shock at the bar prices there – I almost did.

48. Pavilion Kiosk in the Town Gardens: 1914

Aside from the fact that this kiosk café does a nice bacon butty, and aside from the fact that it's an agreeable spot to sit with a cuppa or lick an ice cream in Swindon's Victorian Town Gardens (in Old Town) right by the lovely bandstand, there's a couple of noteworthy facts to know about it.

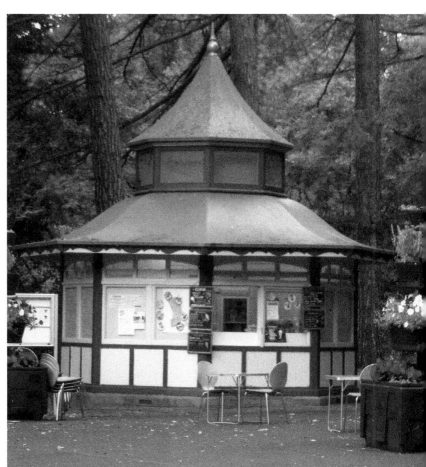

The Pavilion Kiosk Café. (Courtesy of Chris Eley)

In the first instance, built in the works, it forms a link between New Swindon and Old Swindon – possibly the only visible link between the two. It wasn't built as a café though. Constructed in 1914, the kiosk started life as a GWR trade stand. As such it travelled the country, visiting large shows and exhibitions until sold to the council.

The octagonal kiosk with a lead roof and timber frame attainted a Grade II listing in 1986.

49. The Town Garden's Concert Bowl: 1936

Swindon's answer to the Hollywood Bowl, the art deco Concert Bowl lies in the Grade II listed Town Gardens. These lovely leisure gardens sit on the site of old Purbeck stone quarries once owned by the erstwhile lords of the manor, the Goddards.

Town Gardens boasts several interesting and charming features, two of which are the Pavilion Kiosk and the bandstand – itself a Grade II listed structure. Along with those structures, the aviary and a statue of Peter Pan, there's this elegant

The turnstiles and gates. (Courtesy of Chris Eley)

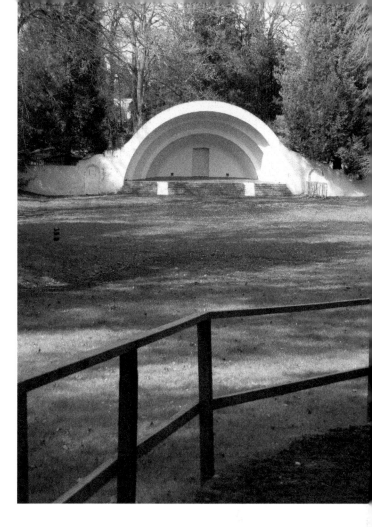

The Concert Bowl. (Courtesy of Chris Eley)

Concert Bowl, which is reminiscent of – and might even have been modelled on – the much larger Hollywood Bowl. There are only a handful of its kind in the country, it seems.

According to Historic England, both the Concert Bowl and the entrance are the design work of the borough surveyor, J. B. L. Thompson, also responsible for the Coate Water diving platform. The mayor of Swindon performed the official opening of the bowl on 6 May 1936.

Referred to in Thompson's drawings as 'Bandstand and Arena' and in the July 1963 edition of the *Civic News* as 'concert bowl and shell', the bowl stands 65 metres south of the park's north-eastern entrance. One approaches it from the south, along a lawn at the bottom of the steep grass-banked valley.

The bowl takes centre stage in its natural amphitheatre formed from the eighteenth-century quarry workings, with grassed banks and mature trees surrounding it. Performance attendees access the amphitheatre via an entrance porch with iron turnstiles and brick pillars.

Over the past sixty-five years the bowl has hosted many a musical event. From big bands to bhangra – Swindonians have listened and danced to it all here.

50. The Old Nursery, Marlborough Lane: 1936

I love a bit of symmetry and circularity in a story, and those elements are present in spades – in every sense – with this house.

One George Davis from Bisley in Gloucestershire, born around 1872, began his working life as a plasterer. Somewhere between 1901 and 1909 he gave up plastering and went into the nursery/market garden business. By the first decade of the 1900s George, his wife and their young son lived at No. 64 Devizes Road in Old Town, with his market garden encompassing 20 acres of land stretching between Devizes Road and Marlborough Lane. This was a sizeable business that must have served Old Town and beyond.

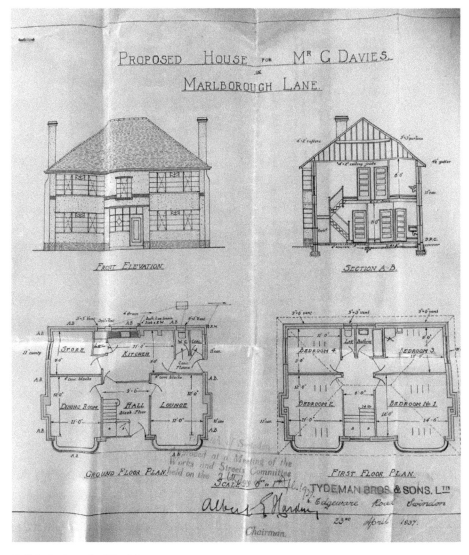

Builder's plans for The Nursery.

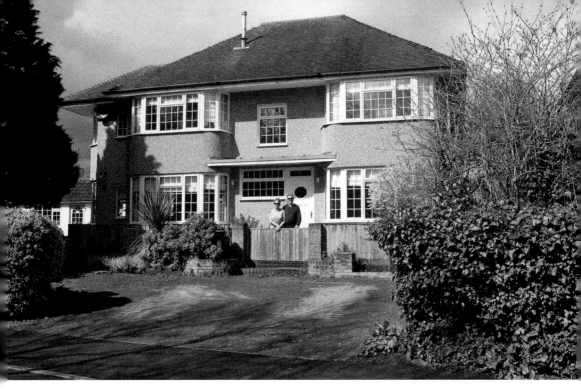

The Old Nursery today, recognisably the same house. (Courtesy of the current owners)

Given that the house now known as The Old Nursery wasn't built until the mid-1930s, one assumes that the family continued to live in Devizes Road until then. Tydeman Bros Builders built the 1936 house. A long-established company, it had, by 1917, lost twenty-two men to war, Tydeman's son included.

George Davis died in 1938, aged sixty-six, so he didn't get to enjoy the house he built for long. Swindon and Wiltshire business directories from 1939 up to the mid-1940s show The Nursery, Marlborough Lane, under the ownership of one Christopher George Davis, the only son and only child of George Davis, the founder.

The Davis story gets a little hazy now. It seems the Davis land had a compulsory purchase order placed on it. This I think, though haven't been able to verify without spending tedious hours, that I'll never get back, wading through bound copies of council minutes, happened sometime in the 1950s. As a result, and at length, the George Davis & Son business went into floristry, with first a shop on the *Queen Elizabeth II* liner, then premises on Wood Street. Both long gone now.

Fast forward to the present owners of the house, resident there around twenty-five years now. Arguing that there's an art to growing, it's fitting that a husband and wife team, comprising artist David and Carole Bent, now live and work from the property and the studio they built in the Old Nursery's garden. And that mention of the word 'garden' brings us back to George Davis. Because both Carole and David are keen gardeners and support caring for their locality with community gardening as well as maintaining their own garden.

Long gone George Davis' nursery may be, but I like to think his spirit lives on in The Old Nursery garden and the well-tended public flower beds of Old Town.

Acknowledgements and Sources

My thanks go to Swindon's splendid local studies library and the equally fabulous Wiltshire and Swindon History Centre in Chippenham for their excellent research facilities.

Both Swindon Town Football Club and Swindon Cricket Club have been super helpful in supplying photographs and information. The same goes for Sophie Cummings, curator at Swindon Museum and Art Gallery, Robert Slade apropos Rodbourne Manor and Roger Ogle for West Swindon.

Too many people to mention have been more than forthcoming with information and photographs. Thank you everyone.

Sources Used Include:

British Listed Buildings website: https://britishlistedbuildings.co.uk
Carter, Graham, Swindon Heritage and Alfred Williams Society
Child, Mark, *Art Deco Building, a Monograph*
Child, Mark, *The Swindon Book*
Gray, Michael, 'A History of Prospect Terrace, Old Town, Swindon'
Gray, Michael, 'Notes and Supporting Material for a Lecture on
 SwindonTown Hall'
Gray, Michael, 'The Wyvern Theatre'
Historic England
Lydiard Park website: https://www.lydiardpark.org.uk
St Mary's Lydiard Tregoze: http://www.stmaryslydiardtregoze.org.uk
Swindon Advertiser – assorted articles
Swindon Bottles: http://www.swindonbottles.co.uk
 'Swindon: The Legacy of a Railway Town: The Royal Commission on the
 Historical Monuments of England'
Swindon Web: http://www.swindonweb.com
The Richard Jefferies Society
Yucca Villa: http://www.yuccavilla.com